COLLINS • Learn to draw

Flowers

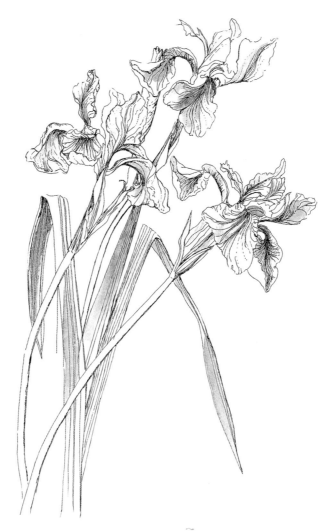

CHARMIAN EDGERTON

First published in 1997 by
HarperCollins*Publishers*
77-85 Fulham Palace Road
Hammersmith
London W6 8JB

Collins is a registered trademark of
HarperCollins Publishers Limited

The HarperCollins website address is
www.**fire**and**water**.com

01 03 05 04 02
4 6 8 10 9 7 5 3

© HarperCollins*Publishers*, 1997

Produced by Kingfisher Design, London
Editor: Diana Craig
Art Director: Pedro Prá-Lopez
Designers: Frances Prá-Lopez, Frank Landamore

Contributing artists:
Shirley Felts *(pages 44, 57, 59)*
Jo Oakley *(page 11 bottom)*
Jackie Simmonds *(page 55)*
Valerie Warren *(pages 27, 49, 52 bottom, 61 top)*

A catalogue record for this book is available from the British Library

ISBN 0 00 413359 5

Printed by Midas Printing Ltd, Hong Kong

743.7
Edge

CONTENTS

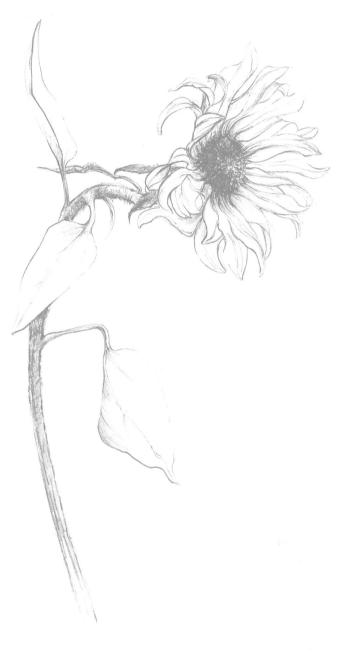

Introduction

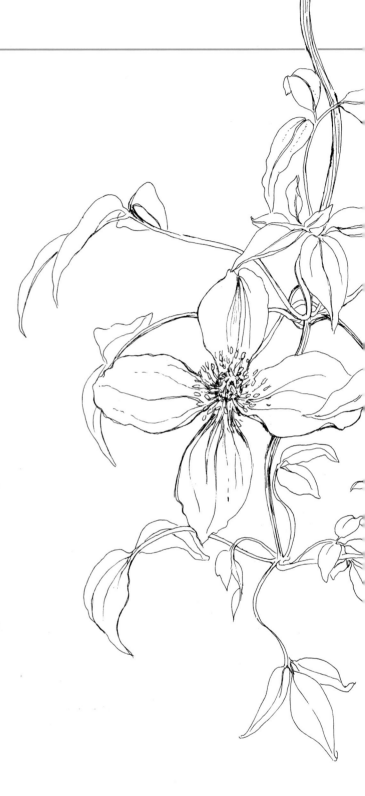

Throughout the centuries artists have turned to flowers for their inspiration, attempting to capture either the simple perfection of a single flower or an elaborate arrangement of exotic blooms. Perhaps you have never tried to draw flowers before? Well, by choosing to read this book, picking up paper and pencil and tentatively attempting to draw, for example, a vase of flowers you will be following in a long tradition of flower artists, both amateur and professional.

Flowers and plants offer limitless means of artistic expression. A single flower observed throughout its growth period will provide you with countless drawing opportunities from tiny bud to mature flower. Apart from the winter months, flowers are easily available throughout the year. They will inspire you to draw or sketch their transient beauty, whether they are growing naturally in their own habitat, massed on a holiday balcony, stuffed carelessly into a jug on a kitchen table or carefully tended in a hothouse.

In this book I will be encouraging you to look at flowers from many viewpoints – not just to observe solitary blooms, but also to draw them in their own environment and as subjects in a still life. As you work your way through the chapters, you will learn about the different drawing materials and surfaces that you can use, and how to combine these for the most effective results; about the underlying form of flowers and how to convey and emphasize this form with light and shade; and about the many varieties of textures and patterns that plants and flowers reveal.

You will also, I hope, learn to make full use of your sketchbook, taking it with you on walks in the country, on holiday, or whenever you are away from home. A sketchbook can provide a visual 'memory bank' of all those flowers and plants that have caught your eye, whether they are swathes of wild flowers in a meadow, or geraniums spilling out of a flowerpot.

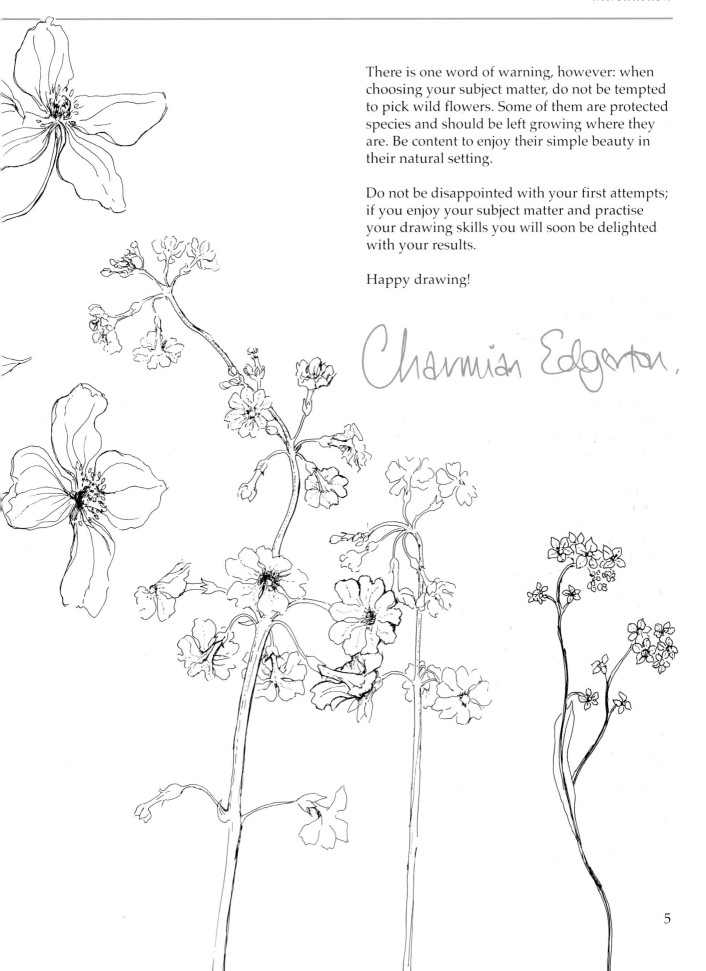

There is one word of warning, however: when choosing your subject matter, do not be tempted to pick wild flowers. Some of them are protected species and should be left growing where they are. Be content to enjoy their simple beauty in their natural setting.

Do not be disappointed with your first attempts; if you enjoy your subject matter and practise your drawing skills you will soon be delighted with your results.

Happy drawing!

Charmian Edgerton.

Tools and Equipment

There is an extremely wide choice of exciting drawing materials available which can be overwhelming for the beginner. My advice is to keep your initial selection of tools and equipment simple. Buy the best that you can afford and add to your collection as your confidence grows.

Pencils
Flowers and plants can be drawn successfully in a diversity of media, but to begin with I suggest that you choose the humble pencil. Pencils are the most versatile of drawing instruments and capable of an extraordinary variety of marks. They range from the hard 9H through the middle-of-the-range HB, to the softest, 9B.

Propelling pencils and clutch pencils are available in hard and soft leads and are very useful for sketching; also, they do not need endless sharpening.

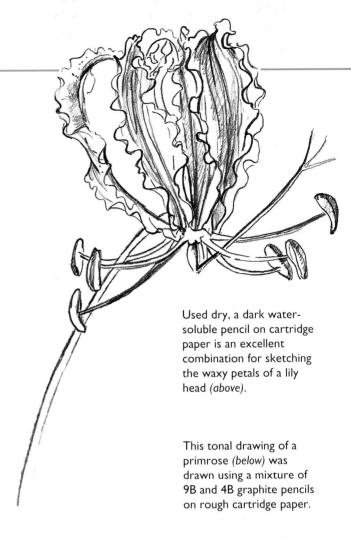

Used dry, a dark water-soluble pencil on cartridge paper is an excellent combination for sketching the waxy petals of a lily head (above).

This tonal drawing of a primrose (below) was drawn using a mixture of 9B and 4B graphite pencils on rough cartridge paper.

Remember always to carry a knife or pencil sharpener with you, as the softer pencils wear down very quickly. Explore the potential of as many different pencils as possible, and the effects they create. Don't be afraid to smudge and gently erase areas, combine soft pencils with hard, and moisten your water-soluble pencils.

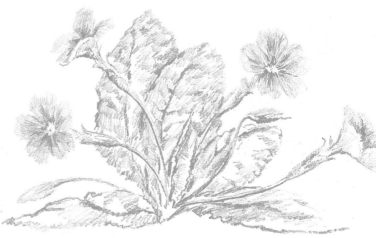

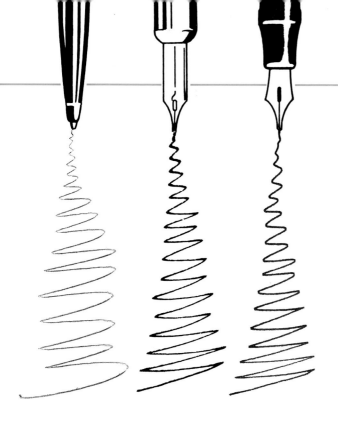

Dip pens are also pleasant to use and there is an interesting range of both fine- and square-tipped nibs available. Experiment with square-tipped nibs for the flower stalks and use the finest nib of all – the mapping pen – for describing the flower stems.

Fountain pens have different-coloured cartridges and are a delight to take sketching, giving continuous line in various sepias, blacks and blues.

Ballpoint pens are a variety of pen I would avoid. Although they move swiftly over the paper, they are inclined to leak, smudge unpleasantly and are generally rather messy.

Pens

There are a variety of pens on the market producing a wide range of effects.

Felt-tipped pens come in an enormous selection of line widths and colours. Do experiment with the combination of wide and fine tips; the wide tips, for example, are good for defining the petals of a daisy, while the fine tip describes the petal's fine veins.

Technical pens are invaluable if you wish to take a more botanical approach to your flower drawing. Their nibs come in different thicknesses of line, the finer the line the lower the number. They need careful washing after use as their fine nibs become easily clogged.

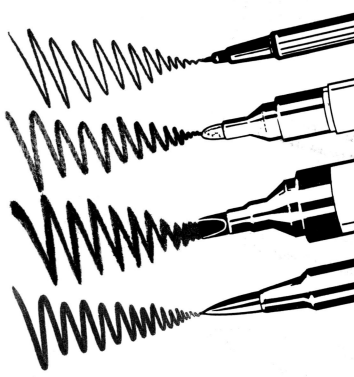

The same primrose as the one opposite: here the crisp, precise lines of technical pen create a quite different look.

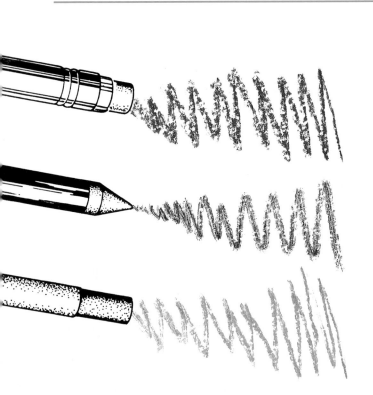

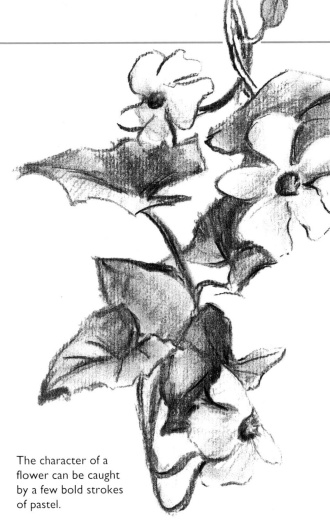

The character of a flower can be caught by a few bold strokes of pastel.

Pastels and crayons

These offer an exciting alternative to the more precise line of pens and pencils.

Pastels produce a rich, crumbly line. They work best on a rough or textured paper. To begin with, I suggest that you buy a small box or a few single sticks. You might also like to try pastel pencils; they are much harder and can be sharpened with a knife.

The powdery line of the pastel chalk can be blended with a paper torchon and smudged with a clean finger. It is ideal for large-scale work. For smaller-scale detail, chalks can be broken into smaller pieces; they can also be used on their sides or their tips.

Conté crayon has a distinctive crisp line and is easy to blend.

Wax crayons and **oil pastels** are rather greasy media which make mistakes difficult to erase. They come in a dazzling array of colours, but need to be handled carefully to avoid overworking.

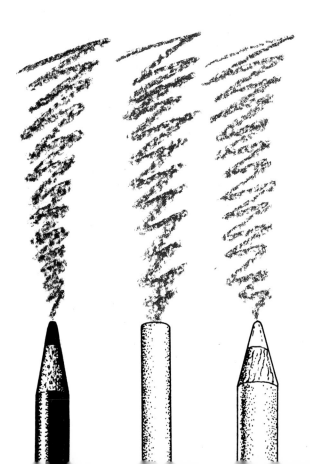

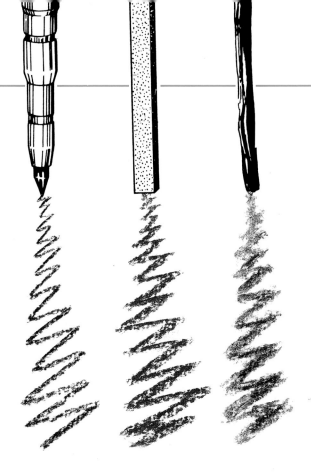

Graphite stick is a favourite medium. These chunks of pencil lead are available in various softnesses. They can be used at speed for gestural drawings, or sharpened to a point for more detailed work.

The side and point of a **9B** graphite stick was used to define the petal shapes of this rose while the graphite point was used delicately to sketch the leaves.

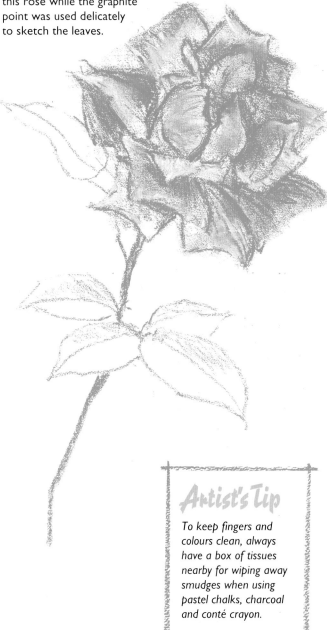

Charcoal and graphite

Both of these are versatile media. For a really bold approach to drawing flowers, choose charcoal. Charcoal is one of the oldest and most traditional of drawing implements.

Charred charcoal twigs encourage a loose and free style of drawing. They are particularly useful for preliminary sketches and are always used in conjunction with pastel at the beginning of a pastel drawing. The charcoal stick may be used from every angle, with varying effects. Though not a delicate medium, it can be sharpened to a point on fine sandpaper. Pressure on the point will result in drawings of velvet black, while broken pieces used on their sides will produce delightful tonal qualities in shades of grey. Do not absent-mindedly rest your hand on your drawing as charcoal smudges very easily. Always spray your drawings with hair spray or fixative.

Compressed charcoal is another alternative to the charcoal twig. It comes in both pencil and stick form and is cleaner to handle. The resulting drawings are often darker in tone. Do experiment by using both together.

Artist's Tip

To keep fingers and colours clean, always have a box of tissues nearby for wiping away smudges when using pastel chalks, charcoal and conté crayon.

Brushes and wet media

There is a wide range of brushes on the market. Because they vary so much in size, shape and quality, it is difficult for the beginner to make the right choice. Always buy the highest quality that you can afford and try at least to have one sable in your collection. It will last for years, and if looked after will never lose its shape. Also include some synthetics, particularly if you are going to use waterproof ink and acrylic paint.

Buy a small selection of variously shaped brushes. I suggest one round No. 4 for creating generous washes, a pointed No. 1 and No. 2 for fine lines, and a square-tipped No. 3 which is invaluable for flat, controlled areas. All brushes need careful washing after use, especially after use with waterproof ink or acrylic paint, which can dry hard.

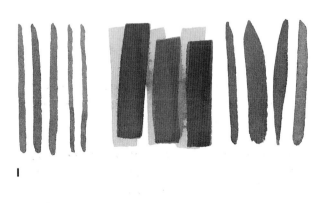

I

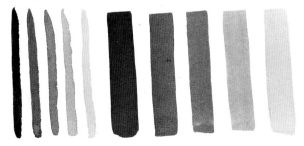

2

I These brushmarks were made with *(from left to right)* a small, pointed brush; a flat brush; and a large, pointed brush.

2 Watercolour tone can be progressively reduced by adding more water, as shown by these strokes using different dilutions.

3

5

4

6

3 For an even layer of strong watercolour, add darker washes to a light wash while still wet.

4 To prevent colours 'bleeding' into each other, let the first layer dry before adding the next.

5 For a soft, blurry effect, paint watercolour onto paper that has been slightly dampened.

6 Ink or concentrated watercolour on damp paper will spread into swirls and blotches.

Black ink, water, pen and brush can be combined successfully to produce traditional black line-and-wash drawings. Use waterproof ink to prevent your line drawing dissolving, and use non-waterproof Indian ink or watercolour for your wash.

As always, though, do experiment. Inks come in a bright array of colours, are easily mixed and look wonderful painted over dry black ink.

Watercolours are sold in small blocks or pans, tubes or in concentrated liquid form. Depending on the amount of water used, the colours can be as strong or as delicate as you like. Watercolours happily mix with other media, and areas of dry watercolour may be enlivened by strokes of chalk pastel, conté and oil pastel.

Broad brushstrokes of diluted Indian ink on damp watercolour paper give this sunflower a certain spontaneity.

Oil pastel works well as a wax-resist drawing. A watercolour or water-based ink wash over the top will not adhere to the greasy pastel, and the underlying drawing will show through.

Gouache, like watercolour, is a water-based paint, but if applied thickly is dense and opaque. It is very useful for obliterating mistakes and will easily cover pencil and pen lines.

Acrylic paint, though it closely resembles oil paint, is water-based. It is quick-drying and excellent for building up translucent layers of colour. There are various media that can be added to acrylics for different effects. I suggest that you try texture paste for added interest to flower petals and stamens.

When using paints and inks, always have a jug of water and at least two water containers near at hand. Change your water often to keep your colours clean. Old plates and cups are ideal for mixing inks and holding individual colours.

This bunch of Provençal lavender was painted with a No. I sable brush on dry watercolour paper using concentrated paint and very little water in a technique called 'the dry brushstroke'.

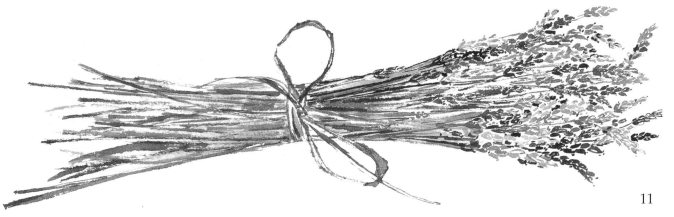

Newsprint is very inexpensive, which makes it good for practising and rough sketching.

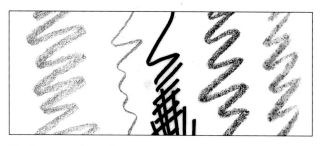

Tracing paper is semi-transparent so that you can lay it over other images and trace them.

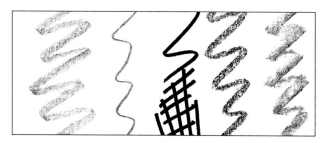

Stationery paper, usually available in one size, has a hard, smooth surface that works well with pen.

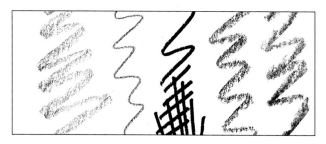

Cartridge paper usually has a slightly textured surface, and is one of the most versatile surfaces.

Surfaces

The texture of your paper will determine the character of your drawing. There are no strict rules about which medium to use on which surface, but some combine better than others. Pastel chalks and conté, for example, are best applied to a rough, textured paper while technical pens work better on a smoother surface. Experiment with coloured papers; it's exciting to draw with white chalk on a dark surface, while brown conté looks good on a background of rich cream.

Watercolour paper may be hand-made or machine-made and comes in three surface textures: *hot-pressed*, *not* (i.e. not hot-pressed), and *rough*. Watercolour paper will not buckle when dampened and stretched.

Cartridge paper is suitable for all media, even thin applications of pastel. It is available in rolls, sheets and sketchpads.

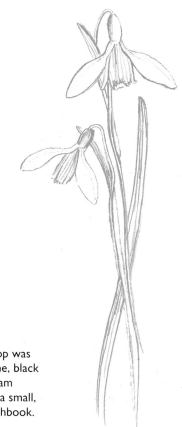

This little snowdrop was sketched with a fine, black felt-tip pen on cream cartridge paper in a small, pocket-sized sketchbook.

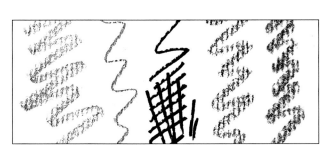

Ingres paper, in various colours and with a lightly ridged surface, is ideal for pastel and charcoal.

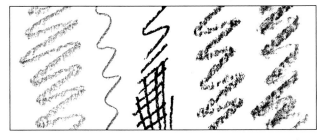

Watercolour paper is thick and absorbent, and has a rough surface. It is good for wet media.

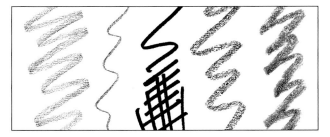

Bristol board is stiff and has a smooth finish that makes it a good surface for pen drawings.

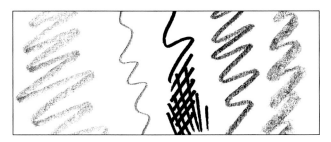

Layout paper is a semi-opaque, lightweight paper that is very suitable for pen or pencil drawings.

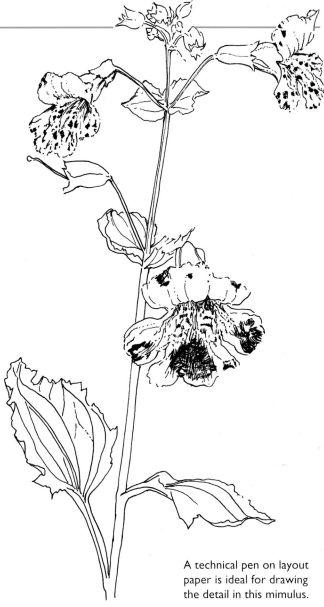

A technical pen on layout paper is ideal for drawing the detail in this mimulus.

Pastel papers and boards come in many textures and colours. Their rough texture or 'tooth' will hold many layers of pastel pigment.

Photocopy paper and **layout paper** are very smooth and ideal for working in pen and ink.

Bristol board is ideal for ink washes.

Newsprint and **wrapping paper** are cheap, and should not be despised.

Tracing paper is very useful for planning a composition and tracing a design.

13

Choosing the Right Medium

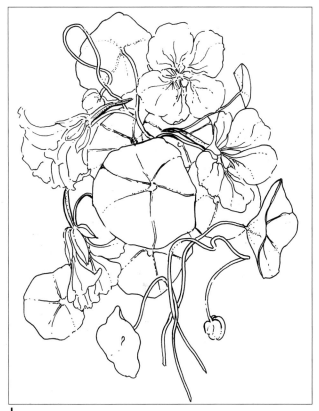

1

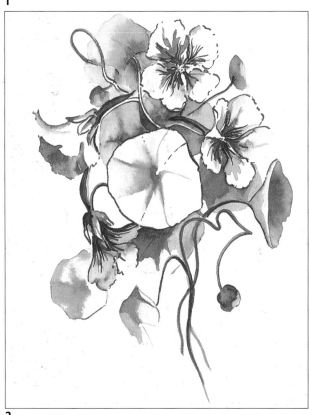

2

With different combinations of media and surface you can create quite different effects. Though these six designs are the same, each drawing evokes its own atmosphere and mood according to the medium and the background.

The first drawing is in 0.1 technical pen on layout paper. A technical pen will glide with ease over the white surface enabling you to record a plant with cool, botanical detail.

The second drawing is done in a water-resistant felt-tip pen and Indian ink wash on Bristol board. The flowing line of the wet brush gives both depth and texture to the flowers and leaves, while fine lines have been traced with the tip.

The third drawing is sketched in 9B and 3B pencils on cartridge paper. Varying the pressure on the pencil lead creates light and dark tones. A soft putty eraser lifted out highlights.

Pastel on Ingres paper lends light and atmosphere to the fourth drawing. The soft pigment can be gently smudged to create form and volume. Hard edges can be brushed away to give an illusion of depth.

The fifth picture is drawn in conté with white chalk highlights on rough cream cartridge paper. The side of the conté stick adds texture to the leaves while the point details the flower centres.

The sixth design is drawn with a sharp stylus on black scraperboard. Scraperboard is very effective for strong black and white designs. You can paint over mistakes with black ink. Do not lean your hand on the scraperboard: it is marked by perspiration.

1 Technical pen on layout paper

2 Felt-tip pen and Indian ink on Bristol board

3 Pencil on cartridge paper

4 Pastel on Ingres paper

5 Conté crayon and white chalk on cartridge paper

6 Stylus on scraperboard

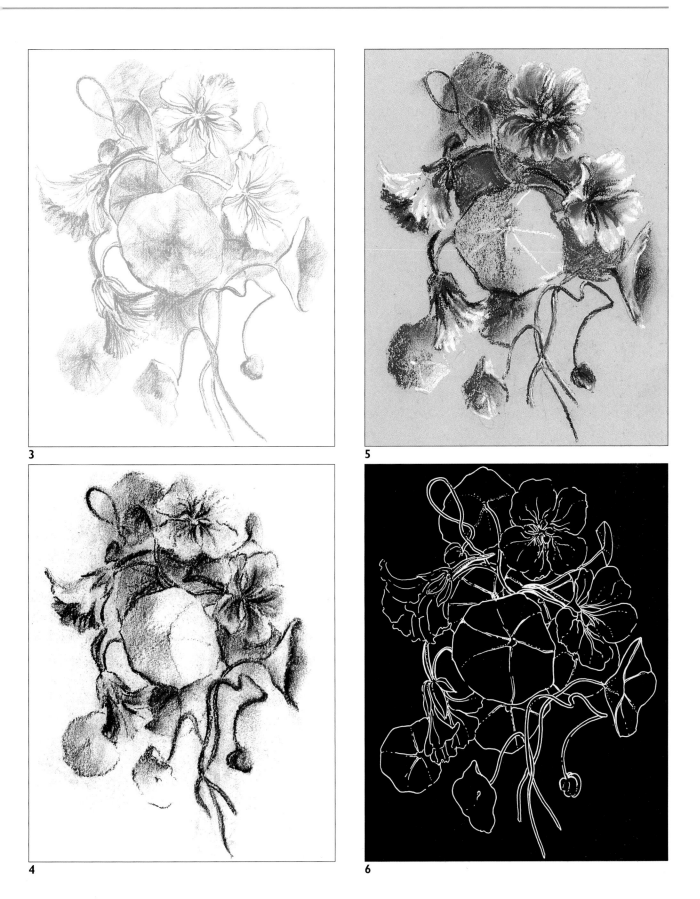

3

5

4

6

Selecting your Subject

It can be a little difficult at first to decide on your subject matter as there are so many flowers from which to choose. I suggest that to begin with you keep things simple. Do not rush off to an expensive flower shop or raid country lanes but look very carefully in your garden or window box for inspiration. You will be surprised at the simple beauty of a garden weed and amazed at the complexity of many leaf forms.

Certain flowers have a strong emotional appeal so let yourself be bowled over by a cheeky sunflower or beguiled by that tiny violet. Having a feeling for your subject will result in a sympathetic drawing no matter how amateur your first efforts seem.

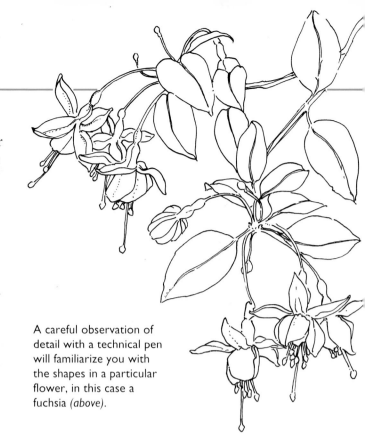

A careful observation of detail with a technical pen will familiarize you with the shapes in a particular flower, in this case a fuchsia *(above)*.

The humble buttercup is as rewarding to draw as a more complex flower. Here you can see the three stages building up to the final drawing *(below)*.

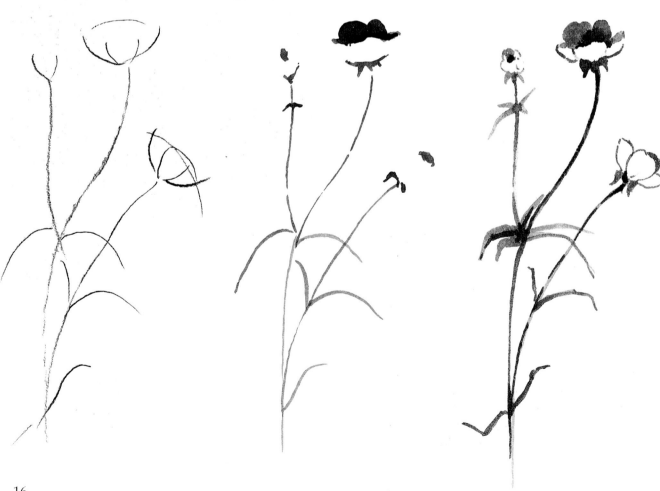

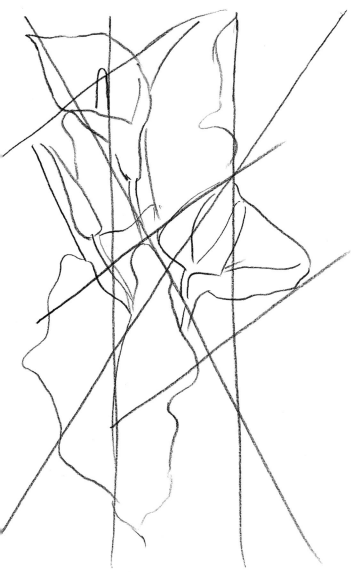

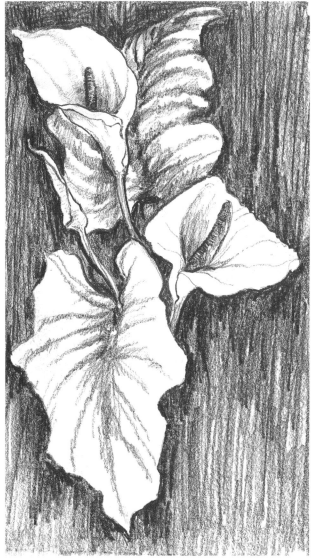

Mood and atmosphere

Certain flowers will evoke a feeling of time and place. Think, for example, of geraniums on a sunny terrace or bluebells in a shady wood. Occasionally flowers such as the waxy orchid can be quite sinister, while lilies always retain a sense of mystery.

Forms and textures

Explore the texture of flowers and plants. Some are fleshy, some paper-thin. Look at the growth pattern of a plant – does it creep tenaciously upward like ivy, float elegantly like fuchsia, or droop heavily down like wisteria?

1 Some flowers, such as the arum lily, present obvious vertical and diagonal lines. Work these out first *(above left)*.

2 Having established the structural lines, the lily can then be placed against a dark background to create a sense of mystery *(above)*.

Artist's Tip

Always draw your directional lines very lightly so that they can be easily erased in your final drawing.

Where to look for flowers

When they start to draw, many people feel more confident working on a still life of flowers, chosen and arranged to their personal liking. However, don't forget that flowers can be found in many different locations. The most obvious choice would be your local park. Here you can decide whether to draw flowers in 'close up' or sketch a herbaceous border. Be prepared, though, for the occasional curious onlooker.

Many parks or municipal gardens have botanical hothouses. They are a rich source of inspiration if you want to draw exotic plants such as the orchid and other rare breeds. Investigate your own or other people's vegetable patch (get permission first). Vegetable flowers, such as those of the courgette, can be unexpectedly beautiful. On cold, wet, winter days explore a conservatory for new ideas, and you might be surprised at what is flowering in a neighbour's greenhouse!

Drawing on holiday

A holiday beach might seem an unlikely place to find flowers, but have you considered the beauty of sea holly or looked at the waving fronds of seaweed in rock pools?

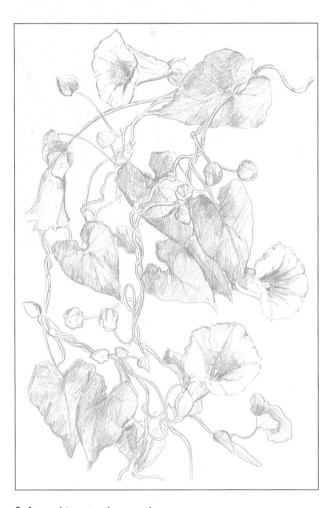

Soft graphite pencils record the intricate twists and turns of the well-named bindweed *(above)*.

To simplify a complicated subject, it is a good idea to make a series of thumbnail sketches exploring the various design possibilities, as shown here.

Be selective: look for the most dominant structural lines and combine these with the strongest shapes to create the most pleasing arrangement.

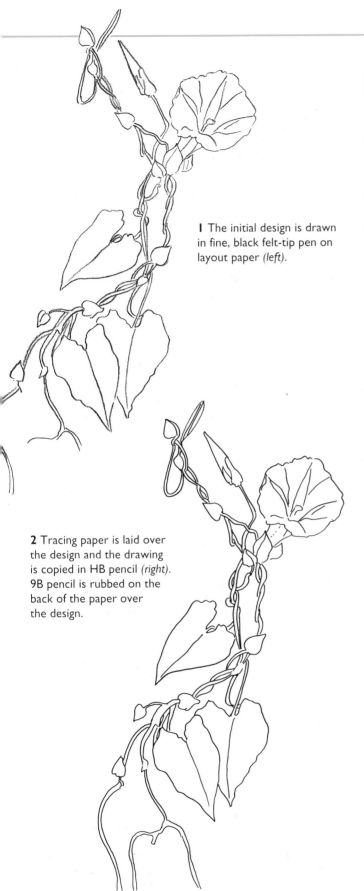

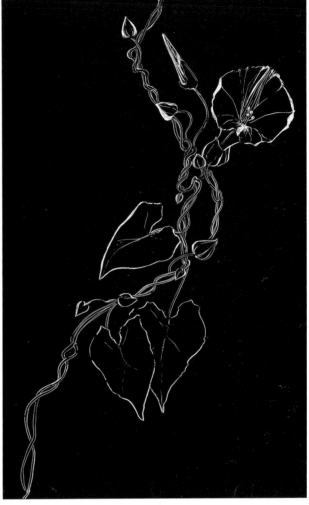

1 The initial design is drawn in fine, black felt-tip pen on layout paper *(left)*.

2 Tracing paper is laid over the design and the drawing is copied in HB pencil *(right)*. 9B pencil is rubbed on the back of the paper over the design.

3 The tracing paper is laid over the scraperboard and secured by tape. The design is then traced with an H pencil. The paper is removed and a stylus used to draw over the pencilled lines *(above)*.

Hotel and restaurant terraces are often decorated with a wealth of flowering pots and hanging baskets, and many towns are bright with flowers, plants and flowering shrubs.

Waterfalls, rivers and ponds are hopefully rich with plant life and are excellent locations to explore for ideas. Water lilies are a delight to draw and it is pleasant to sit beside a sunny pond and to imagine that for a moment in time you are Monet drawing in his Giverny garden.

Structure and Form

In order to draw plants and flowers successfully you need to know a little about their structure and form. Do not be tempted to draw them in botanical detail to begin with; concentrate instead on their basic shapes. To make your flower drawings seem convincing, they must look as three-dimensional as possible.

Formation and shape

Most flowers are symmetrical so study the petal forms and how they are centred in the flower. Compare, for example, the petal formation of a daisy with that of the more complex snapdragon.

Learn to look at flowers as simple shapes; many flowerheads break down into geometric shapes, such as the circle and the triangle. Beginning with these forms will help you to understand the structure and the proportion of plants.

Suitable media

Choose a medium that best describes the form. The crispness of a technical pen evokes the delicate veins on a petal, while soft pencil creates ruffles of carnation petals. Sharp conté pencils describe open gladioli trumpets, and strong charcoal strokes add volume to the lily.

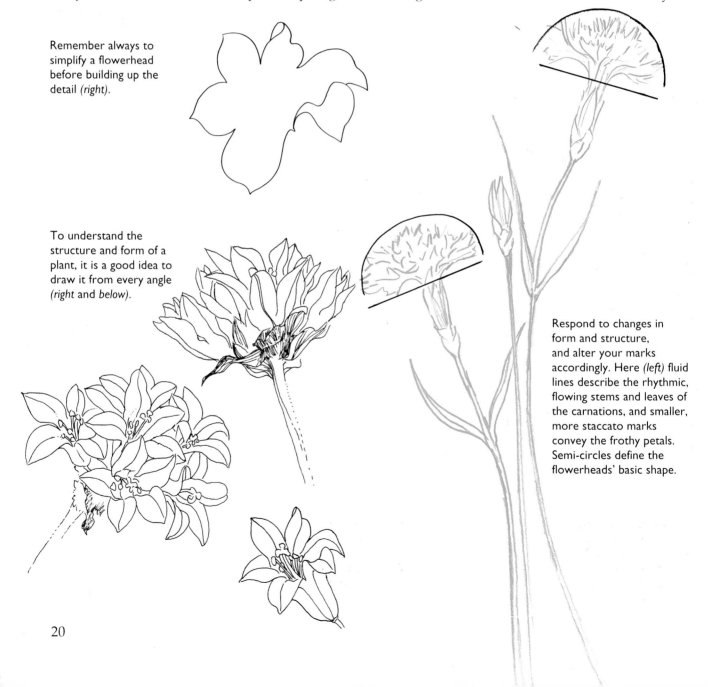

Remember always to simplify a flowerhead before building up the detail (right).

To understand the structure and form of a plant, it is a good idea to draw it from every angle (right and below).

Respond to changes in form and structure, and alter your marks accordingly. Here (left) fluid lines describe the rhythmic, flowing stems and leaves of the carnations, and smaller, more staccato marks convey the frothy petals. Semi-circles define the flowerheads' basic shape.

20

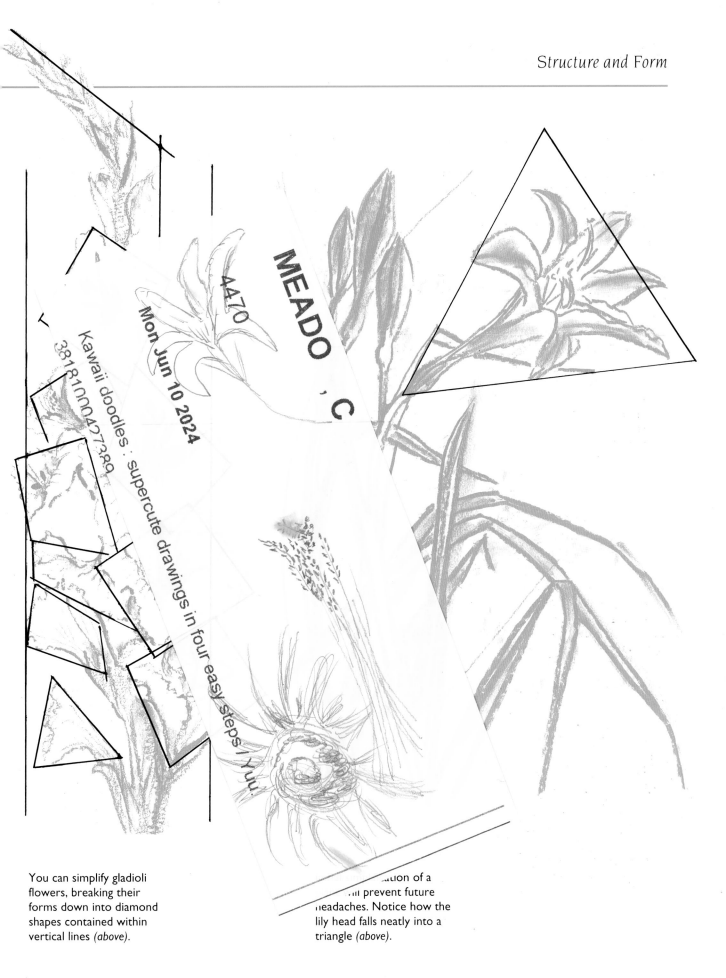

MEADO , C

4470

Mon Jun 10 2024

Kawaii doodles : supercute drawings in four easy steps / Yuu

38181NN042738q

You can simplify gladioli flowers, breaking their forms down into diamond shapes contained within vertical lines *(above)*.

...ation of a ...ill prevent future headaches. Notice how the lily head falls neatly into a triangle *(above)*.

Looking at leaves

Leaf shapes are often as beautiful and as complex in their structural form as flowers themselves – in fact, the character of a flower is often defined by its leaf structure. The nasturtium flower would be quite different without its convoluted stalks and umbrella-shaped leaves, and the intricately textured primrose leaf makes a perfect foil for the delicate primrose flower.

Before you start to draw your leaves, observe carefully how they grow along the stem. Some leaves grow opposite each other, others grow alternately, and some, such as those of the daffodil, from the base of the plant.

Artist's Tip

If a stalk or stem is hidden by a leaf, make sure that you draw it in the correct place when it reappears.

Here, the form of the primrose leaf is described in minute detail with a fine pen *(above)*.

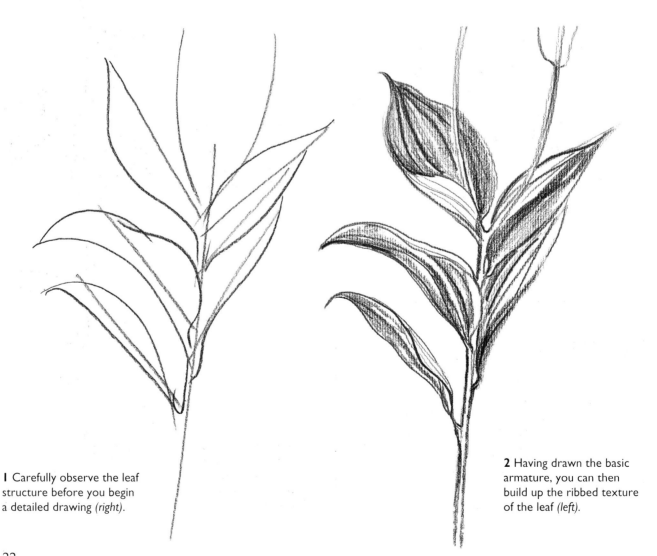

I Carefully observe the leaf structure before you begin a detailed drawing *(right)*.

2 Having drawn the basic armature, you can then build up the ribbed texture of the leaf *(left)*.

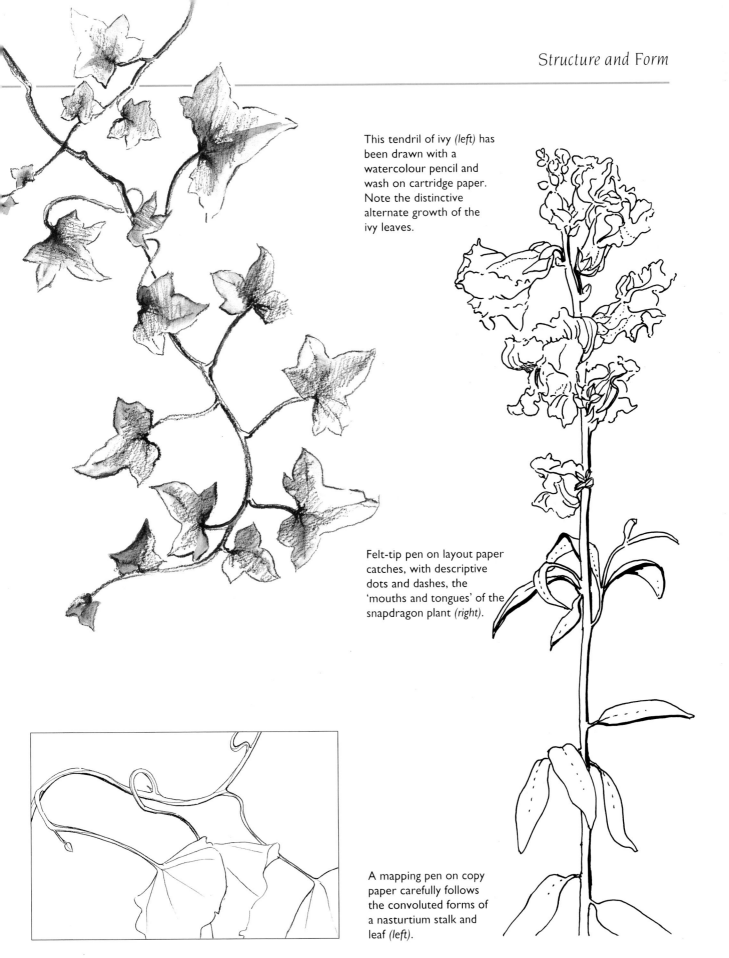

This tendril of ivy *(left)* has been drawn with a watercolour pencil and wash on cartridge paper. Note the distinctive alternate growth of the ivy leaves.

Felt-tip pen on layout paper catches, with descriptive dots and dashes, the 'mouths and tongues' of the snapdragon plant *(right)*.

A mapping pen on copy paper carefully follows the convoluted forms of a nasturtium stalk and leaf *(left)*.

Proportion and Perspective

The beginner is sometimes worried by the words 'perspective', 'proportion' and 'foreshortening'. However, if you follow a few simple rules there is nothing to be afraid of.

Perspective is the 'art of illusion', making objects that would appear flat and lifeless seem three-dimensional. 'Proportion' refers to the relative size of different parts of a plant or flower.

Foreshortening is a form of perspective. An easy way to understand it is to choose a flowerhead such as a daisy or a chrysanthemum and hold it against a straight edge – a pencil will do – and

notice as you tip it away from you how the size decreases, and how the circle becomes an oval.

The right angle
To measure the correct angle of a leaf, hold your pencil at arm's length, at a right angle to your arm. Compare the angle of the leaf with that of the pencil. Then lightly draw a line at this angle on your paper.

1 & 2 Once you have observed the correct angles and proportions of leaves, you can concentrate on form and texture.

Drawing a dotted line for the hidden curve of a leaf *(below left)* will help you to understand leaf shape better.

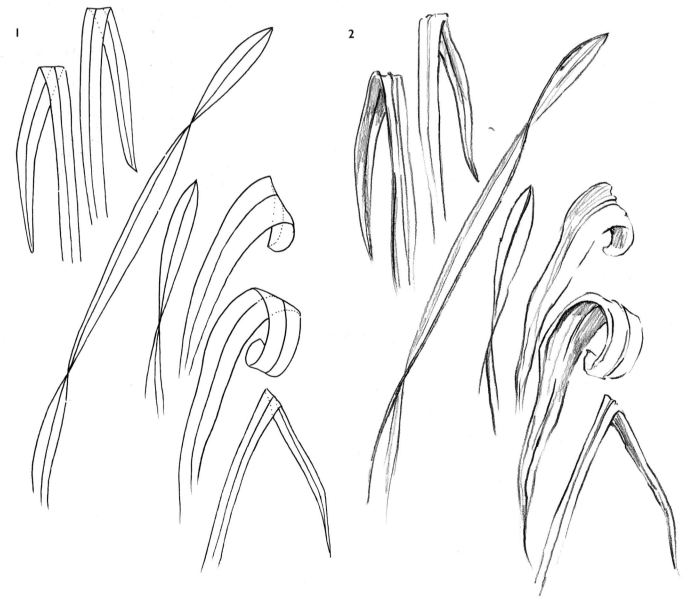

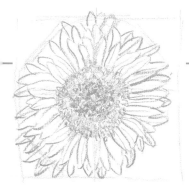

1 These three drawings show the effects of perspective. This daisy *(left)*, viewed full on, fits neatly inside a square.

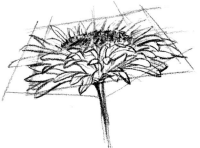

2 As the flower is tipped away from you, the parallel lines on either side of the square narrow into the distance *(above)*.

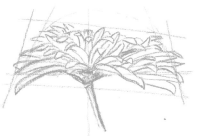

3 The centre of the daisy has completely disappeared and we now have a narrow side profile *(above)*.

Sometimes the veining and texture of a petal will explain its perspective. The lines on these iris petals *(above* and *right)* show us how, under the effect of perspective, parallel lines meet at a vanishing point.

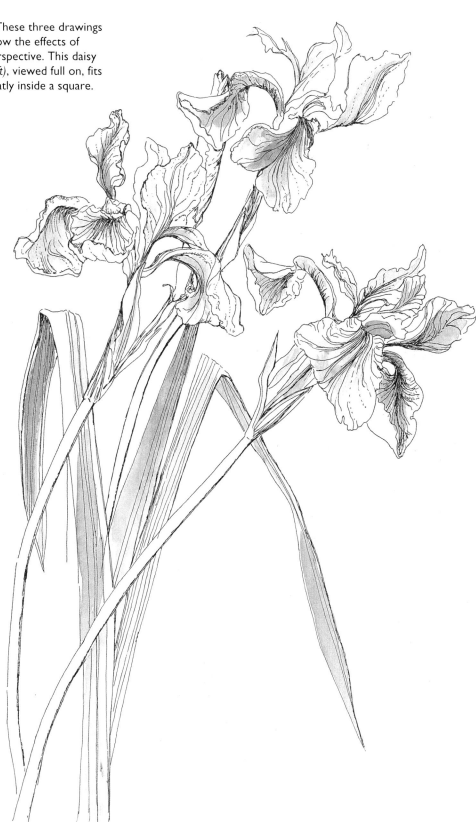

How to measure

As well as measuring angles, you can also measure size and so ensure that all parts of your drawing are in the right scale.

To take a visual measurement, hold a pencil vertically at arm's length, closing one eye and squinting at your subject. Measure your subject sight-size – that is, the exact size that you see it. If your drawing is large, your sight-size measurement can be doubled or trebled.

To understand how this works, you might like to do a similar exercise to the technique I used in the drawing below. In *Polyanthus and Brown Jug*, I chose the most obvious flowerhead and used that as my unit of measurement. Everything else in the drawing is measured against this flower.

If you methodically measure everything you are drawing – or at least the most important subjects – you will find that all the proportions are accurate and your drawing will look 'right'.

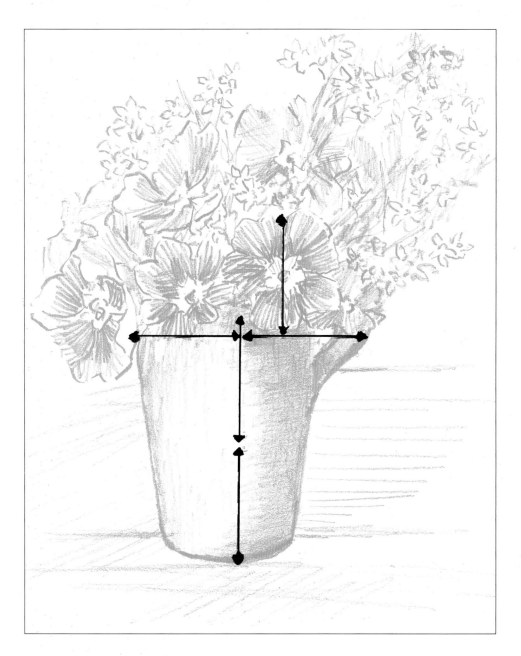

Look carefully at the arrows in this drawing *(left)*. Two flowerheads are equal to the height and width of the jug.

I used this flowerhead *(above)* as my unit of measurement for the flowers in the vase on the left. To measure it, I aligned my pencil point with the top of the flowerhead and slid my thumb down to the base of the flower to mark where it ended.

This drawing of a garden *(opposite)* shows the effects of 'aerial perspective'. This makes objects seem paler in tone and less detailed the further away they are from the viewer.

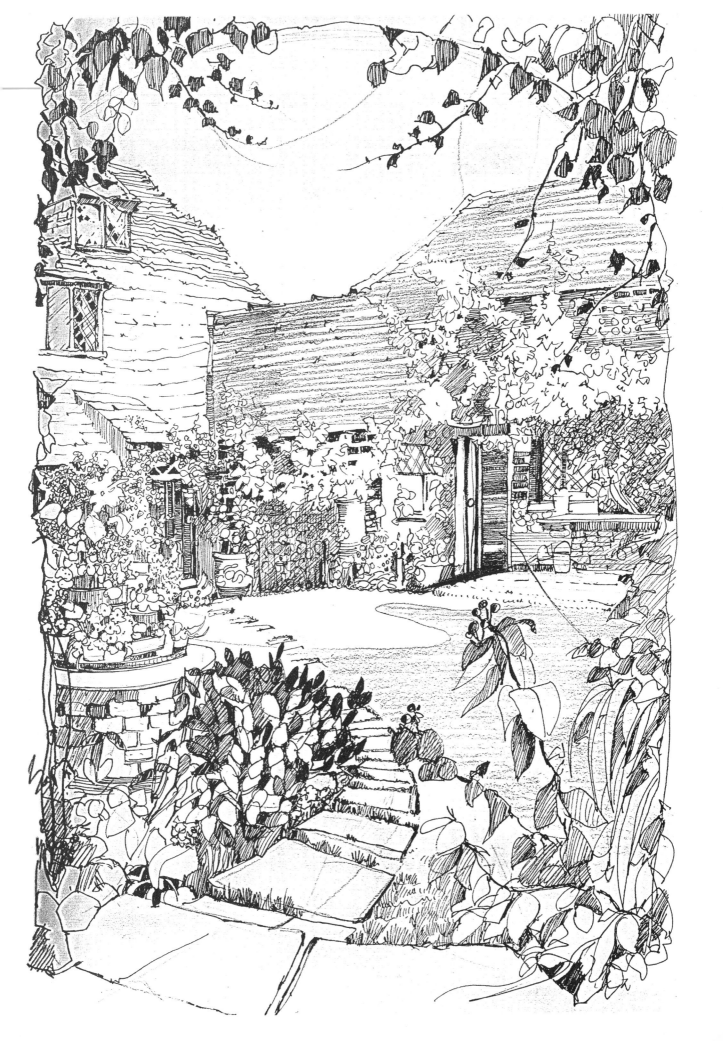

Texture and Pattern

It is impossible to produce a convincing flower or plant drawing without carefully looking at the texture and pattern of your subject matter: surface detail is an intrinsic part of flower petals, stalks and leaves. Imagine a smooth ivy leaf, for example, and contrast it with the spiny thistle, or compare the richly patterned petals of the water mimulus with the simple beauty of the hairbell.

Selecting your medium

A variety of rich textures can be created from a small selection of easily available media. Pencil, charcoal, pastel, ink wash and various pens will all produce a series of descriptive marks. It will, however, take a little time and experience to produce exactly the effect that you want.

It is a good idea to build up your own 'vocabulary' of marks on as many different types of paper as you can find. Always try to use a paper or board that will enhance and add interest to your subject and don't forget that coloured papers add an extra dimension to any drawing. Be adventurous: mix various media and experiment with different textures in the same drawing.

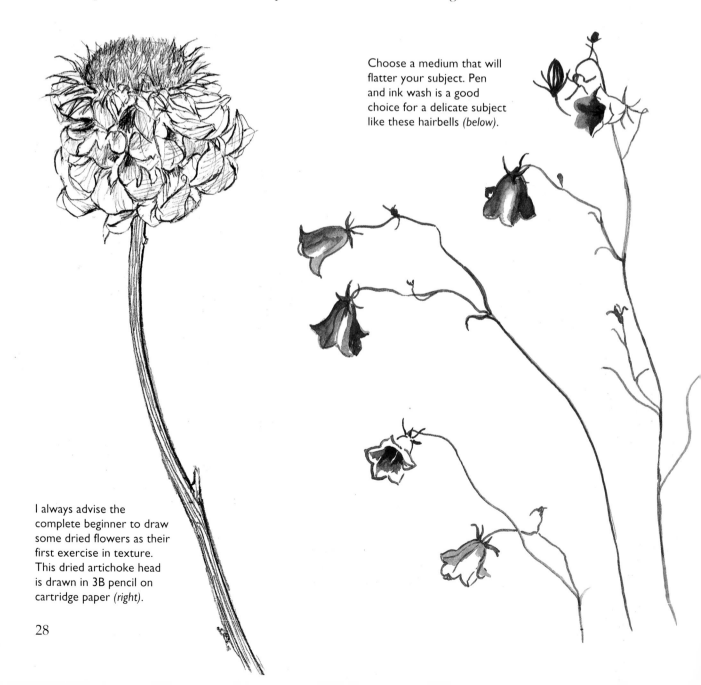

Choose a medium that will flatter your subject. Pen and ink wash is a good choice for a delicate subject like these hairbells (below).

I always advise the complete beginner to draw some dried flowers as their first exercise in texture. This dried artichoke head is drawn in 3B pencil on cartridge paper (right).

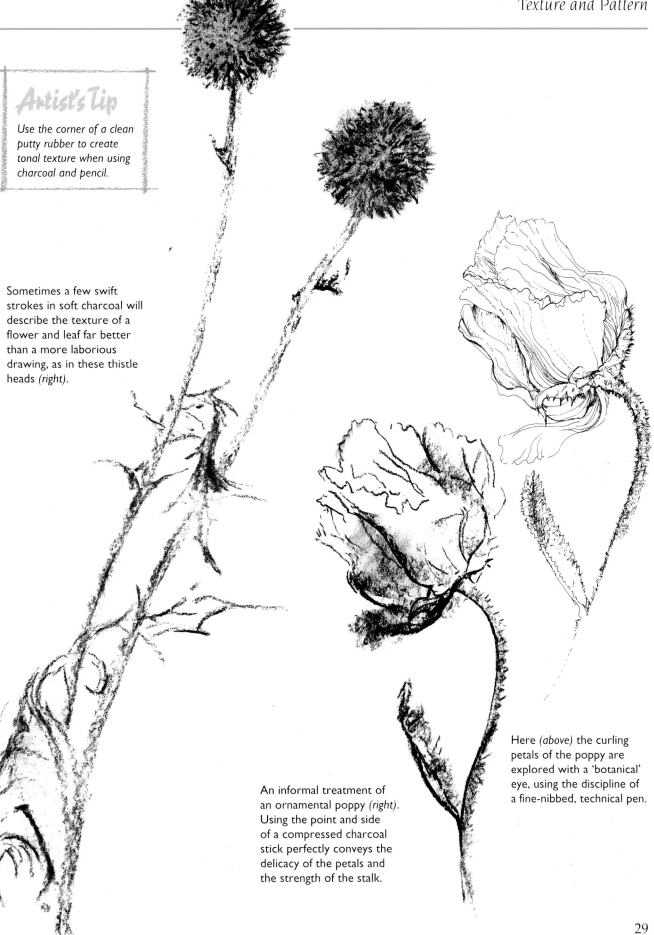

Artist's Tip

Use the corner of a clean putty rubber to create tonal texture when using charcoal and pencil.

Sometimes a few swift strokes in soft charcoal will describe the texture of a flower and leaf far better than a more laborious drawing, as in these thistle heads *(right)*.

An informal treatment of an ornamental poppy *(right)*. Using the point and side of a compressed charcoal stick perfectly conveys the delicacy of the petals and the strength of the stalk.

Here *(above)* the curling petals of the poppy are explored with a 'botanical' eye, using the discipline of a fine-nibbed, technical pen.

29

Responding to texture and pattern

Become sensitive to plant texture and pattern. If you select only a few flowers and compare their petals, you will be fascinated by the various textures. Certain flower petals such as those of the rose have the quality of fine silk, while others are matt or glossy like the buttercup's.

Leaves, too, come in all shapes and sizes; some are shiny smooth, others are rough to the touch. Rhubarb leaves are wonderfully fleshy with thick ribs, the spines of the ornamental thistle when drawn in detail are like miniature modern sculptures, while last winter's rotted leaf looks like fine lace. Some leaves such as those of the geranium and certain houseplants have leaves so patterned that the leaf shape is quite unimportant – all we see is the design.

A detailed study of a small leaf can be done in mapping pen and ink *(left)*. You might even like to use a magnifying glass to look at the surface detail.

Thin white paper and a stick of graphite, charcoal or pastel are all you need to create a satisfying leaf rubbing showing texture and pattern *(right)*.

Build up your confidence by drawing around a geranium leaf with compressed charcoal. Then remove the leaf and concentrate on drawing the leaf's pattern and texture within the outline *(left)*.

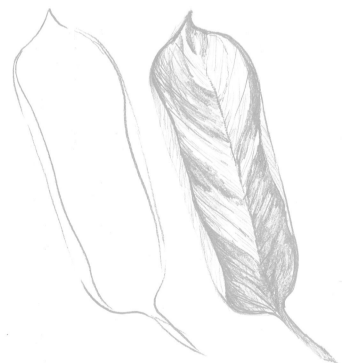

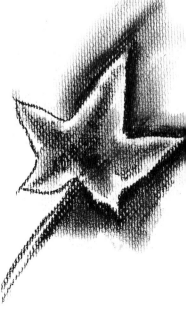

I The form of this laurel leaf *(above)* was first lightly sketched in black conté pencil. The curve has been emphasized to make this shape more interesting.

2 Adding texture has transformed the outline *(above)*. The diagonal veins and stripes enhance the shape, and textural tone emphasizes the leaf curl.

Texture and pattern can add interest to the simplest drawing. Here *(right)* smudged black pastel evokes the smooth surface of an ivy leaf.

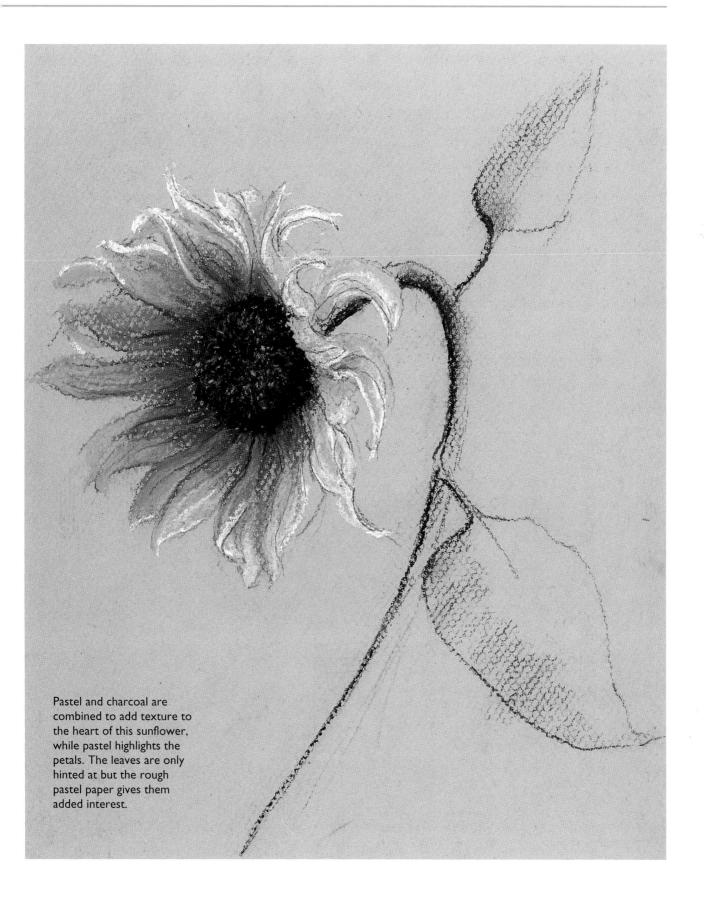

Pastel and charcoal are combined to add texture to the heart of this sunflower, while pastel highlights the petals. The leaves are only hinted at but the rough pastel paper gives them added interest.

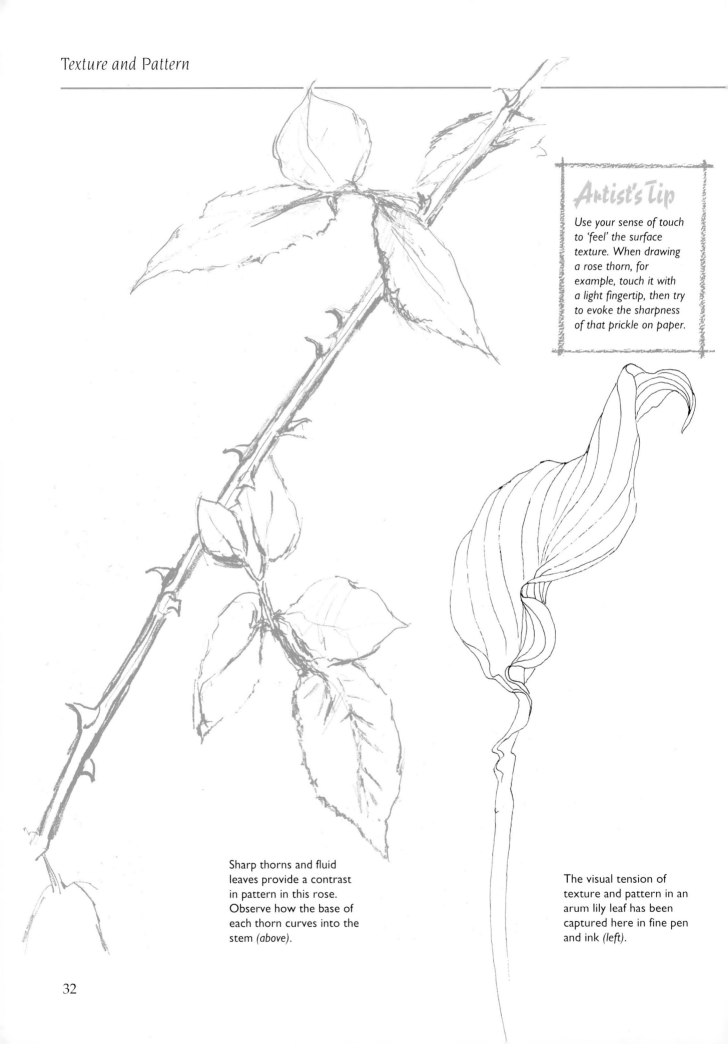

Artist's Tip

Use your sense of touch to 'feel' the surface texture. When drawing a rose thorn, for example, touch it with a light fingertip, then try to evoke the sharpness of that prickle on paper.

Sharp thorns and fluid leaves provide a contrast in pattern in this rose. Observe how the base of each thorn curves into the stem (above).

The visual tension of texture and pattern in an arum lily leaf has been captured here in fine pen and ink (left).

Form and contrast

Do not become so involved with surface detail that you forget the underlying structure of your plant or flower. Sketch in the overall form first and then add your texture or pattern on top.

It is best not to add texture to every area of your drawing but only to the parts that you wish to enhance. For example, if you contrast an intensely textured flower centre with loosely rendered leaves, you will draw attention to the flower. Too large an area of texture of the same density will create a flat and uninteresting area of tone so remember always to vary your marks according to your media.

The pattern and texture of a plant will reflect light and shadow and it is important that your drawings do the same, otherwise they will look flat and uninteresting. Wherever the leaf or flower catches the light or is in shadow accentuate the dark and light areas. If, for example, you are using pastel, work in a small area of contrast with a clean fingertip. When working with pen and ink leave certain areas untouched, others more intricately worked.

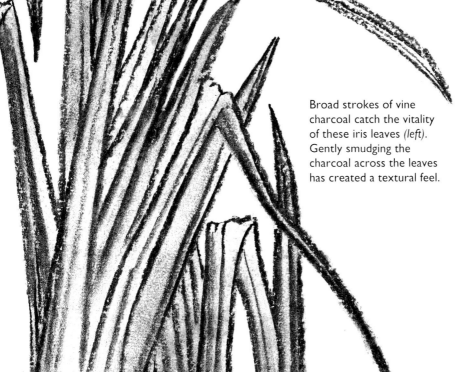

Non-waterproof, black felt-tip pen and wash evoke the delicacy of this unusual house plant *(right)*.

Broad strokes of vine charcoal catch the vitality of these iris leaves *(left)*. Gently smudging the charcoal across the leaves has created a textural feel.

Light and Shade

When you start drawing flowers, keep tonal values simple. Dark tones produce dramatic effects, medium tones balance and harmonize, while light tones accent and highlight.

Experiment with 'high' and 'low key' tones. A drawing in 'high key' is composed of mainly light tonal values while a dark picture with highlights is 'low key'. When looking at flowers or leaves, try not to see them in terms of light and shade. Looking through half-closed eyes will help you to identify their tonal qualities.

Defining form

In nature many natural forms are represented by simple geometric shapes such as the cylinder, the cone and the sphere. Light and shade make these forms look solid and three-dimensional.

Light will highlight the prominent areas of a flower and create shadow in the hollows and parts furthest from the light source. These shadows will fall at the same angle as the light. Light can also be reflected back from the leaves, dappling the underside of the flower.

If you wish to draw a convincing stalk always check where the light is coming from *(above)*.

To make a complex flower appear three-dimensional, simplify the light and shade *(above)*.

Contrasts of highlights and deep shadow make these stylized rose hips look very dramatic *(above)*.

Highlighted curving petals and intense shadows give instant depth to this lily head *(above)*.

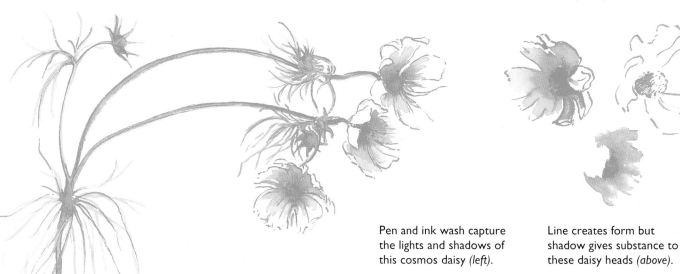

Pen and ink wash capture the lights and shadows of this cosmos daisy *(left)*.

Line creates form but shadow gives substance to these daisy heads *(above)*.

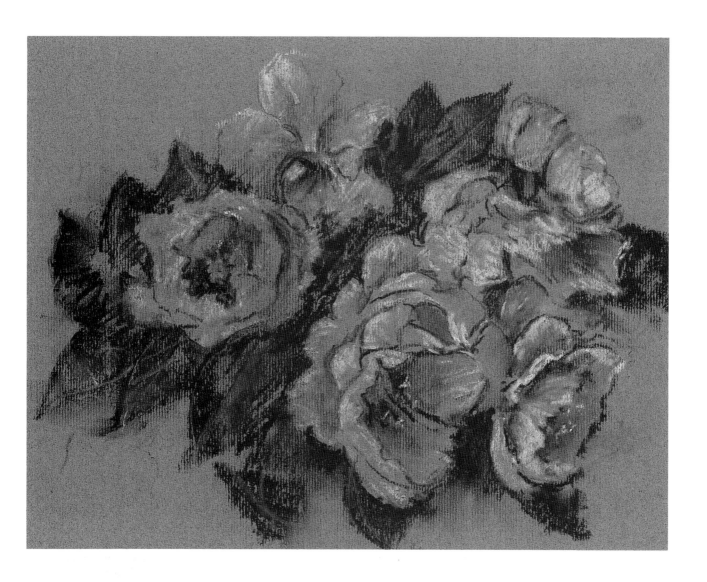

In this 'low key' tonal painting on grey pastel paper, I emphasized the darkness of the rose leaves and exaggerated the highlights on the petals *(above)*.

Use different media to explore different ways of making tonal values. These two drawings were done in soft pencil *(right)*, and felt-tip pen *(far right)*.

Changing light

Different light sources have different intensities, and this can radically alter the appearance of your subject. A still life placed in a shady corner will look quite different when lit by full sun, for example. If you are drawing out-of-doors, remember that natural light changes according to the time of day, creating short shadows in the morning and long ones in the evening.

The closeness of the light source has an effect, too, or there may be more than one light source.

In this sketch of daisies *(left)* the flowers are illuminated from the right. The right-hand petals are sharply drawn while those on the left in the shade are less distinct.

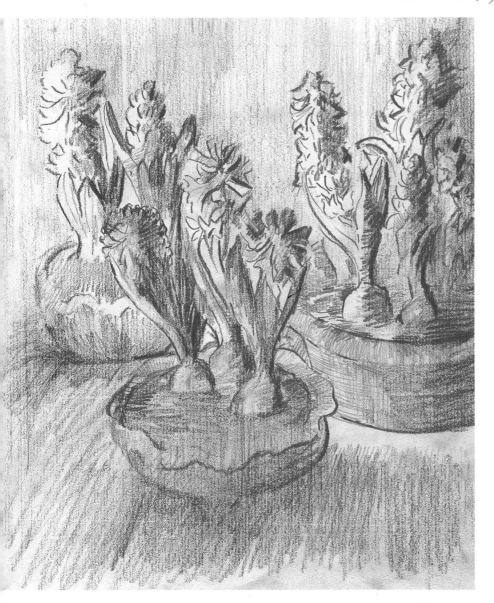

Try drawing flowers *contre-jour* (against the light). These flag irises *(above)* show the exciting possibilities of tonal shape and form in silhouette. Experiment: add bright foreground blooms to your silhouette shapes.

Tonal values are at their most dramatic when bright light meets dark shade. Here the dark foreground shadows usefully anchor the containers to the surface on which they sit *(left)*.

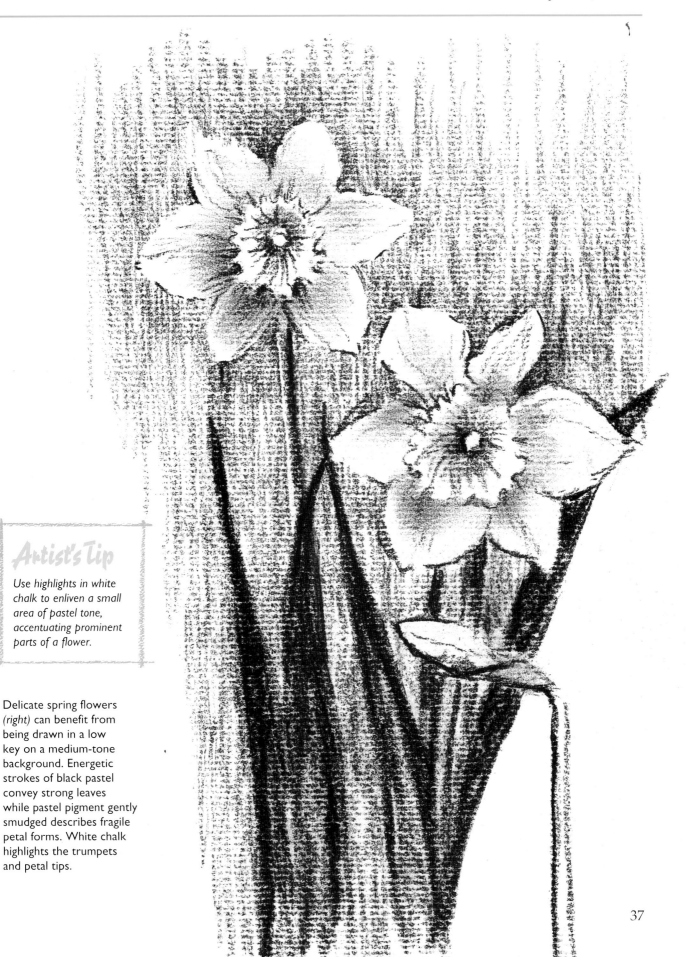

Use highlights in white
chalk to enliven a small
area of pastel tone,
accentuating prominent
parts of a flower.

Delicate spring flowers
(right) can benefit from
being drawn in a low
key on a medium-tone
background. Energetic
strokes of black pastel
convey strong leaves
while pastel pigment gently
smudged describes fragile
petal forms. White chalk
highlights the trumpets
and petal tips.

Looking at Detail

Concentrating on drawing a single flower or a particular collection of leaves is a very useful exercise in observation. A close analysis of the flower, bud, leaf or stalk of a plant will help you to understand its special characteristics.

Leaves and stalks
Seen in close-up, plants have a variety of textures, shapes and patterns. Stalks surprise us with their delicate veining, ridges and thorns. Leaves, too, show a variety of detailed pattern. When drawing leaves in detail, pay particular attention to how a leaf grows from the stalk – some grow in pairs, while others alternate.

It is a good idea to practise your stippling technique on a simplified shape before starting on your flower.

Sometimes it is useful to hold a magnifying glass to a stamen and then try to draw every textural detail.

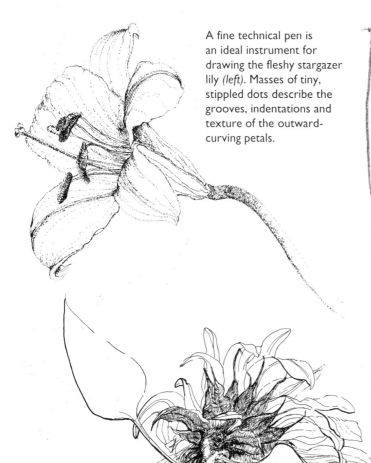

A fine technical pen is an ideal instrument for drawing the fleshy stargazer lily *(left)*. Masses of tiny, stippled dots describe the grooves, indentations and texture of the outward-curving petals.

Detail can help you with structure; the texture on this lily petal helps to describe the form.

On this flower stalk, tiny dots and curving lines have created an almost tangible cylinder.

The combination of precise mapping pen and Indian ink on smooth layout paper is ideal for drawing the detail of petals *(left)*.

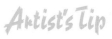

An even amount of detail across your entire subject loses impact, so always decide which area of detail you wish to focus on, and have an area of contrast.

Flower detail

Many flowerheads have complex forms, so examine the construction of a bloom as if it were under a magnifying glass. Count petals, pistils and stamens and look carefully at where and how the petals join the stem.

It is a useful exercise in observation to draw a flower from every side and from unexpected angles. For interesting results, try drawing the same flower in different media.

When drawing flowers in detail as in this pen-and-ink drawing of a foxglove *(left)*, it can be fun to include the occasional 'visitor'.

Drawing the flowerheads, stalks and leaves of the Turk's cap lily *(below)* is an excellent exercise in observation. These flowers look even more exotic in close-up.

Choosing an appropriate medium

Before starting on a detailed drawing do make certain that you have chosen the medium most suitable to your subject and your style of drawing. Remember that a soft, broad medium like charcoal is not suitable for a subject best described with a technical pen, and a great deal of patience is needed to cover a 60 cm (2 ft) square of paper in ink stipple.

I suggest that you start small; choose an A4 sheet of cartridge paper and a selection of graphite pencils, ranging from H to 4B. A fine, waterproof felt-tip pen on smooth card is also a good choice if you want to add a little ink or overlay your drawing with watercolour wash.

Before adding any detail, draw light structural lines to show the form of your subject *(above)*.

Closely observed, these rose buds look like little parcels *(right)*.

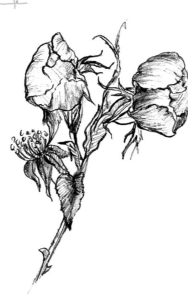

These two drawings of the same rose *(above)*, done in HB and 3B pencil, show it in flower in summer and with hips in the autumn.

Observing changes in growth

If you enjoy detailed work, a satisfying exercise is to make a series of minute observations on the life cycle of a plant or shrub, recording changes in its growth over the year.

From June to October I made studies of the wild roses that you see on this page, recording in my sketchbook the first bud, the unfurling of the flower petals and the final rose hips.

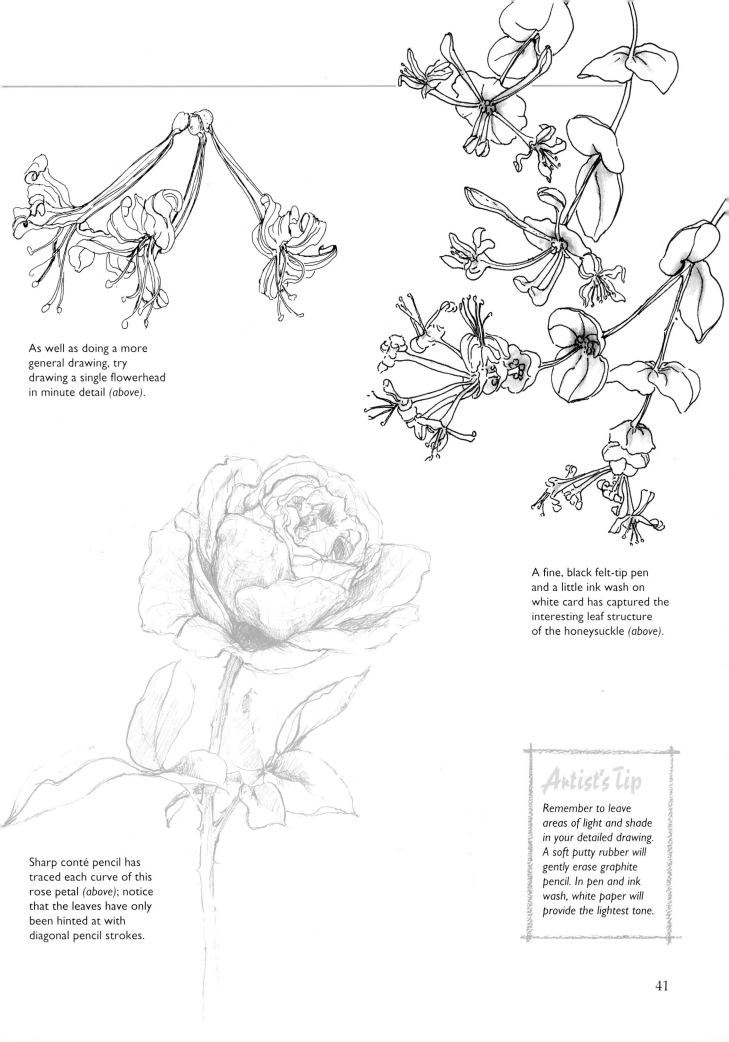

As well as doing a more general drawing, try drawing a single flowerhead in minute detail *(above)*.

A fine, black felt-tip pen and a little ink wash on white card has captured the interesting leaf structure of the honeysuckle *(above)*.

Sharp conté pencil has traced each curve of this rose petal *(above)*; notice that the leaves have only been hinted at with diagonal pencil strokes.

Artist's Tip

Remember to leave areas of light and shade in your detailed drawing. A soft putty rubber will gently erase graphite pencil. In pen and ink wash, white paper will provide the lightest tone.

Sketching

Keeping a sketchbook will encourage you always to keep your eyes open for unexpected plants and interesting flowers, and to record the growth of flowers and plants through the seasons. Sketches made on sunny holidays will immediately evoke the atmosphere of summer in the depths of winter.

If you can, sketch for a few moments every day; your observational skills will improve and you will soon have a very useful 'library' of visual information. When drawing flowers it is very useful to sketch in some of their natural habitat,

as well as making a note of the date and place where you did your drawing.

Experimenting
Use your sketchbook to experiment with different media and styles of drawing. For example, if you like drawing in minute detail in technical pen, try working in a looser, more spontaneous way in your sketchbook.

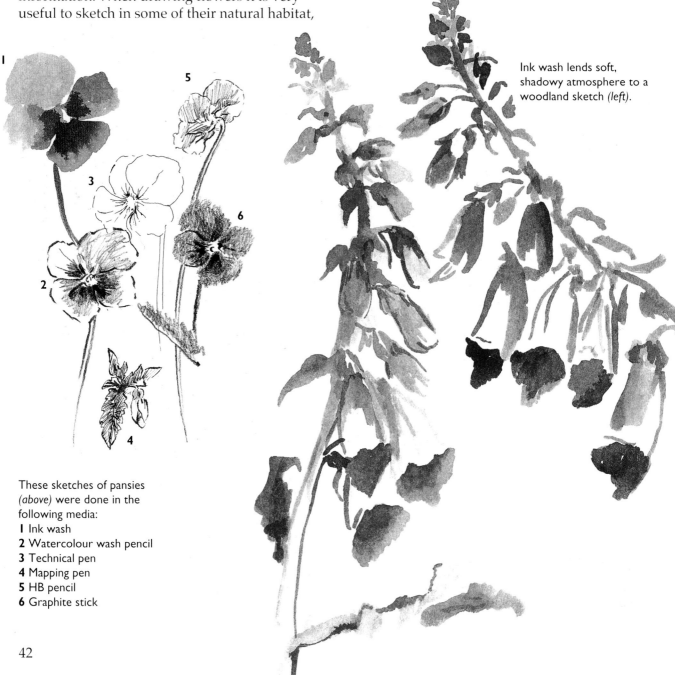

Ink wash lends soft, shadowy atmosphere to a woodland sketch (left).

These sketches of pansies (above) were done in the following media:
1 Ink wash
2 Watercolour wash pencil
3 Technical pen
4 Mapping pen
5 HB pencil
6 Graphite stick

Choice of media

The different media that you use will influence the way that you draw your subject. I suggest that to begin with you use charcoal or watercolour pencils: you will find them easier to control when you are outside than pastels or charcoal (but do experiment with these media at a later date when you have gained confidence).

Working drawings

Remember that your sketches are not necessarily little individual works of art – they are for your own personal reference and satisfaction. Think of them as working drawings, and relax. The successful sketch is the one that 'grabs the moment', and is not too concerned with the finished result.

Artist's Tip

Protect charcoal and pastel sketches by fixing with hairspray or covering with clean paper, and wait until ink wash is dry before closing your sketchbook or the pages will stick together.

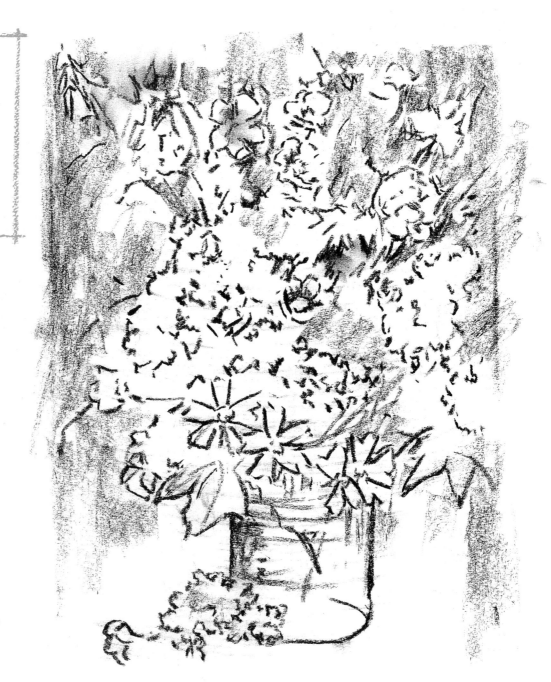

Charcoal pencil on cartridge paper captures the informality of these weeds in a jar.

Much of the appeal of this pencil and watercolour sketch of a waterside scene lies in its loose, relaxed style of drawing.

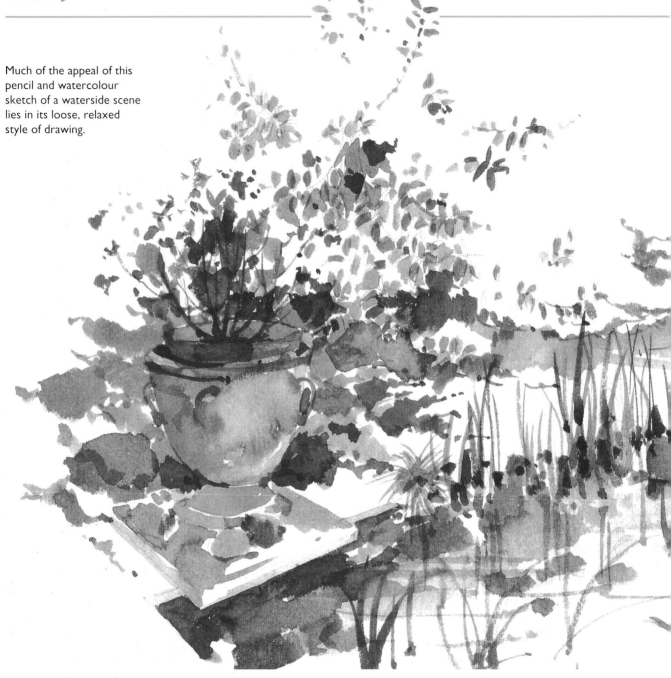

Sketching kit

When out sketching I like to carry a small but versatile selection of equipment. I have an inexpensive fishing tackle box which fits neatly into a canvas backpack. The box holds a few soft graphite pencils, conté pencils, watercolour pencils, compressed charcoal and graphite sticks. I always carry a sharp knife and pencil sharpener, a soft putty eraser and some tissues. For ink and watercolour wash techniques, I have a small tube to carry my two brushes, a bottle of Indian ink and a screwtop jar for water.

My favourite sketchbook (15 x 22 cm / 6 x 9 in) is hardback with medium-weight, cream cartridge pages. A thick elastic band holds the pages secure on a windy day. Stuffed into my backpack will also be a large plastic dustbin bag which has many uses, ranging from protecting the work from the elements to acting as a rug.

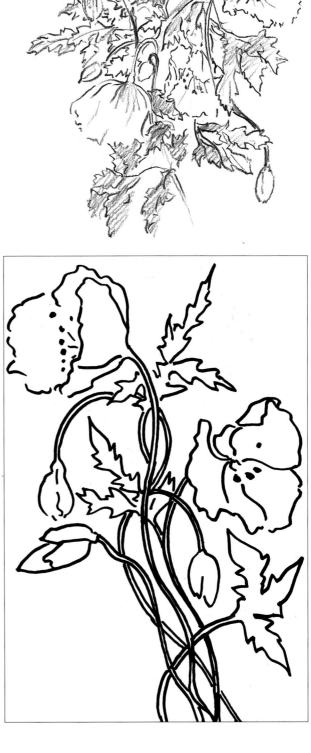

Watercolour pencil on cartridge paper evokes the delicacy of the poppy flowers *(above right)*. The drawing for silkscreen *(right)* still retains the spontaneity of the sketch.

Reference kit

If you want to extend your knowledge of flowers and plants into other areas of art and design, you will refer time and time again to your sketchbook for inspiration.

Sometimes you might deliberately choose to draw certain flowers with the intention of using them in, say, a lino-cut. I selected the poppy sketch above for a simple silkscreen print.

Framing and Composition

A successful flower drawing takes a little planning. Although it may be tempting to do so, try not to include everything that you see.

A good composition is a balance of various elements. Avoid symmetry by placing your subject off-centre for more visual interest, and make sure that your background does not overwhelm the foreground. Before making your final choice, it's a good idea to do a series of thumbnail sketches.

A viewfinder made from two right angles of card will help you to frame and select your final composition (right).

A traditional composition in which the flowers and jug are off-centre, and are viewed from some distance (above).

In a more unusual arrangement, the jug is cut off halfway down (above centre).

Coming in close emphasizes the linear rhythms of the stems, leaves and flowers (above right).

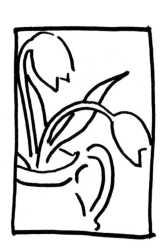

Care needs to be taken when deciding where to cut the flowerhead on the right (above).

A close-up version of the view on the left. The jug and flowers fill the space interestingly (above).

Sometimes it is exciting to focus on one part of the arrangement, in this case the jug's handle (above).

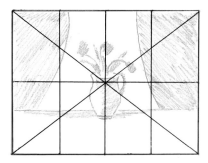

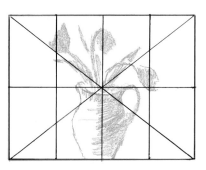

Creating a framework of evenly spaced verticals, horizontals and diagonals helps to organize your composition *(above)*. Avoid such a symmetrical placing, however.

Do not let your paper size dwarf your drawing *(above)*.

Here *(above)* the subject is too large for the paper area, and has been placed too centrally.

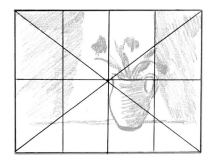

A well-balanced composition provides the foundation of a good drawing *(left)*.

Always choose the correct size and shape of paper for your composition *(below)*.

An unusual vertical subject needs a long, narrow sheet of paper *(right)*.

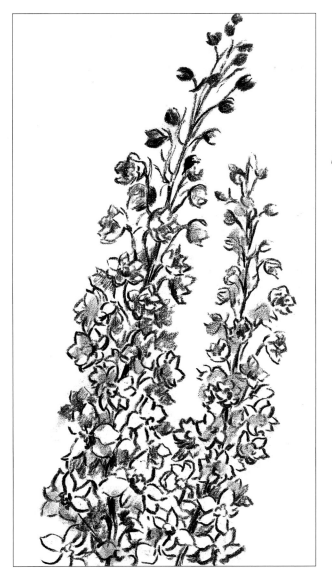

Editing what you see

Remember that you can, if necessary, change or move natural subjects around in order to achieve a successful composition. Choose as your focal point the strongest or most dominant vertical or horizontal line. In the drawing of the chives below, I selected the longest stalk as my focal point. To offset this vertical, I emphasized the horizontal leaves at the plant's base.

Diagonals and verticals create pictorial tension, but look for strong curves and rounded shapes, too. They will add to the rhythm and movement of a drawing. Experiment by combining curves and verticals for visual contrast.

Framing a view

As you can see in the drawing on the opposite page, a group of flowers, shrubs or plants will often act as a successful viewfinder. Here, the flowers literally 'frame' the view and lead the eye; they are as important in this composition as the little church itself.

Note how the church is cleverly off-centre, and the pleasing contrast between its vertical and horizontal lines and the circular plant forms.

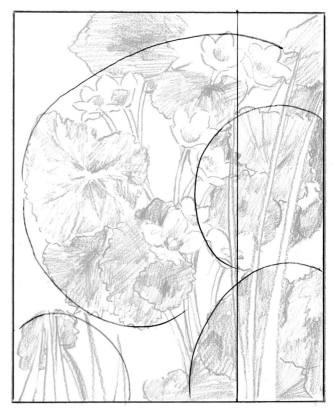

In this sketch of marsh marigolds *(above)*, I deliberately contained the flowers and leaves in rough circles to exaggerate their rounded forms and contrast them with the narrow, vertical reeds.

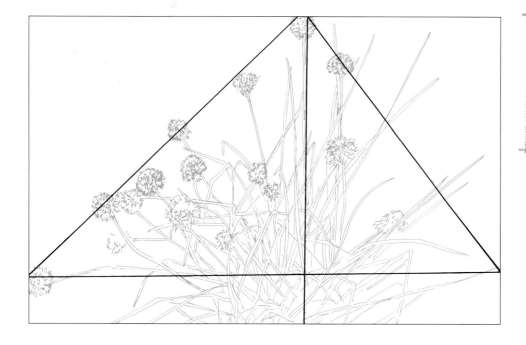

Drawing diagonal lines to confine the leaves and flowers has made an interesting shape *(left)*.

The growth in the foreground provides a natural frame for the church *(opposite)*.

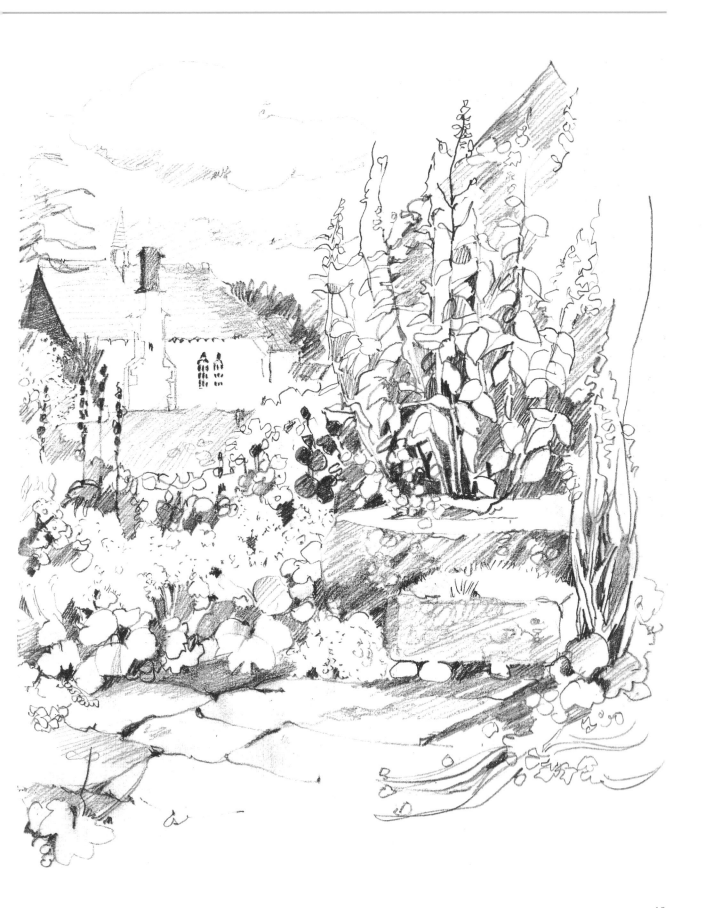

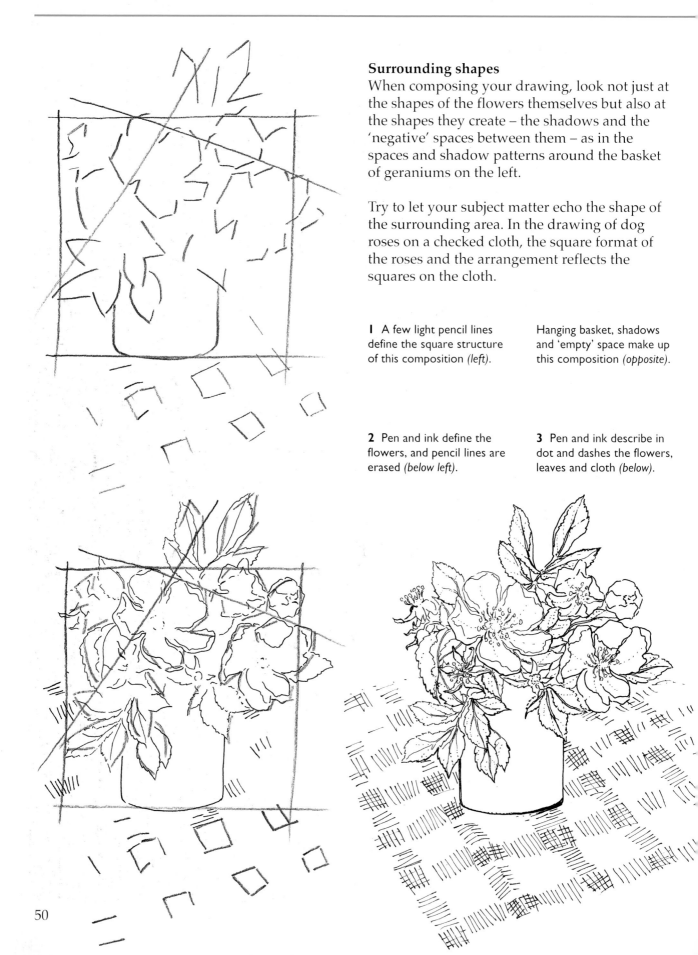

Surrounding shapes

When composing your drawing, look not just at the shapes of the flowers themselves but also at the shapes they create – the shadows and the 'negative' spaces between them – as in the spaces and shadow patterns around the basket of geraniums on the left.

Try to let your subject matter echo the shape of the surrounding area. In the drawing of dog roses on a checked cloth, the square format of the roses and the arrangement reflects the squares on the cloth.

1 A few light pencil lines define the square structure of this composition *(left)*.

Hanging basket, shadows and 'empty' space make up this composition *(opposite)*.

2 Pen and ink define the flowers, and pencil lines are erased *(below left)*.

3 Pen and ink describe in dot and dashes the flowers, leaves and cloth *(below)*.

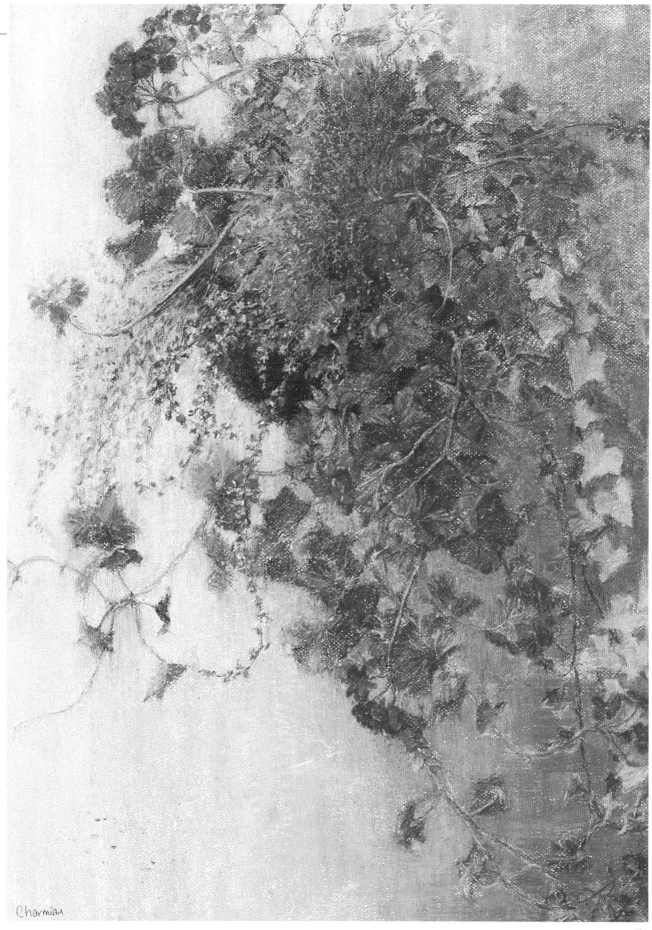

Charmian

In Setting

A single flower drawn in isolation on a blank sheet of paper will look very different when shown in its natural habitat – including a plant's location as background adds another dimension to your drawing. Geraniums pouring colourfully from a sunny window box, for example, generate an atmosphere quite different from that of a geranium used as a still life indoors.

Sometimes the addition of a single detail, such as the shutter in the drawing on the right, will help your picture tell a story.

Artists in residence
It takes a little courage to draw in a crowded restaurant but you can see from the drawing below that the results are worth the effort.

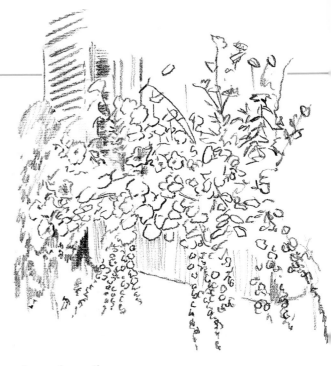

Sometimes a few swift pencil strokes are enough to describe a sunny window box *(above)*.

Sitting outside in the garden of an Italian restaurant, the artist has captured the abundance of flowers lovingly planted in every available container. The jumble of flowers and plants are drawn in a rapid, 'busy' line that reflects the busyness of the restaurant itself.

Most restaurants are quite happy to have artists sketching away – we add to the atmosphere!

Dip pen and Indian ink and 9B pencil evoke the feeling of an Italian trattoria *(left)*. Note that the artist has not drawn each individual leaf, only a few evocative lines.

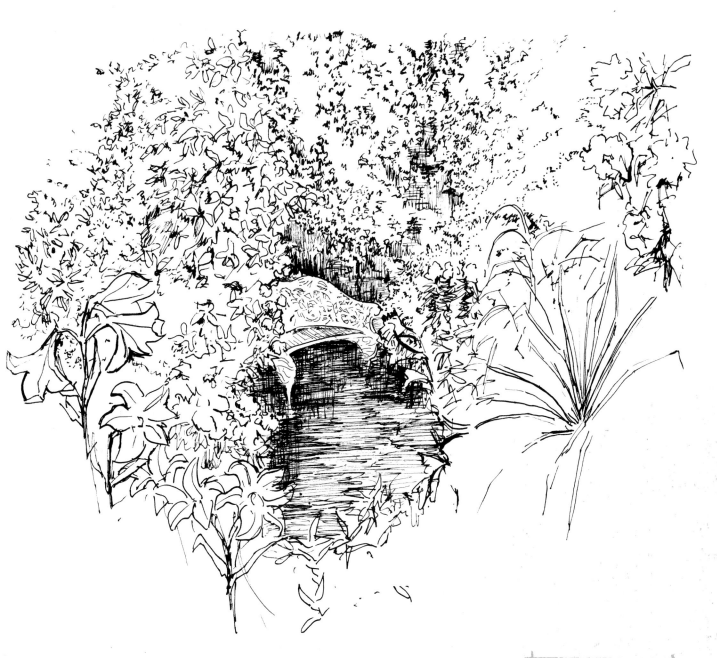

In harmony

When drawing 'in setting', try to choose a scene in which the surroundings complement the subject matter. In complete contrast to the drawing opposite, the sketch above is cool and tranquil, adding mystery to the flowers and plants. The white lilies and Icanthus leaves act as a frame, beckoning us into the secret depths of the garden and inviting us to relax on the shady seat. The composition is deliberately circular to emphasize the tumble of greenery and flowers.

To add depth and tone to this drawing, the artist worked in mapping pen and ink, hatching and cross-hatching.

Artist's Tip

When drawing outside, always go prepared for weather changes; remember to have a good pair of sunglasses, a small umbrella for shade or rain, and something to sit on.

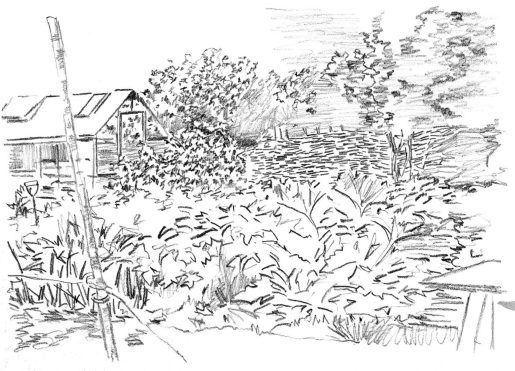

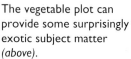

The vegetable garden

Vegetable flowers such as those of the courgette and the spiky, blue flowers of the globe artichoke are fascinating to draw. Marrows and courgettes will climb a picket fence, tangle delightfully with flowery runner beans and make a perfect background for a drawing of chive plants or globe artichokes.

The vegetable plot can provide some surprisingly exotic subject matter *(above)*.

Ink wash captures the waxy delicacy of the water lily *(above)*.

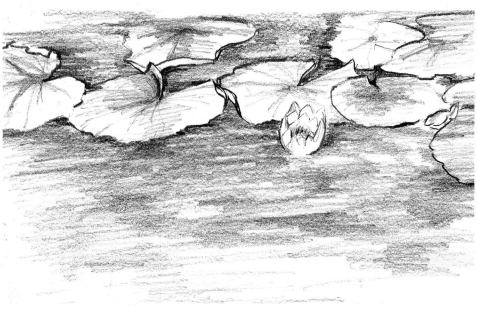

Horizontal lines of shading in watercolour pencil help to keep the petals 'floating' on the water *(left)*.

Aquatic plants

Water plants and flowers are always a challenge to draw but if you take 'the plunge' you will be encouraged by your results. The flowers growing on or near the water will constantly reflect and be reflected in the water's surface. Do not let this confuse you; half-close your eyes to simplify the reflections and remember that the area under the leaf or flower will be the darkest point of tone.

When drawing your flower you will not always see the complete reflection. Look carefully to see how far the plant is from the water's surface – the further away it is the more complete the reflection will be.

If you are tempted to draw plants or weeds in moving water, remember that you must simplify the ever-changing ripples around and beneath the plants, sketching in their tonal values, before drawing the plants themselves.

In this lively pastel drawing, the artist has used flowing lines for the endlessly moving waterfall, in strong contrast to the more static verticals on the banks.

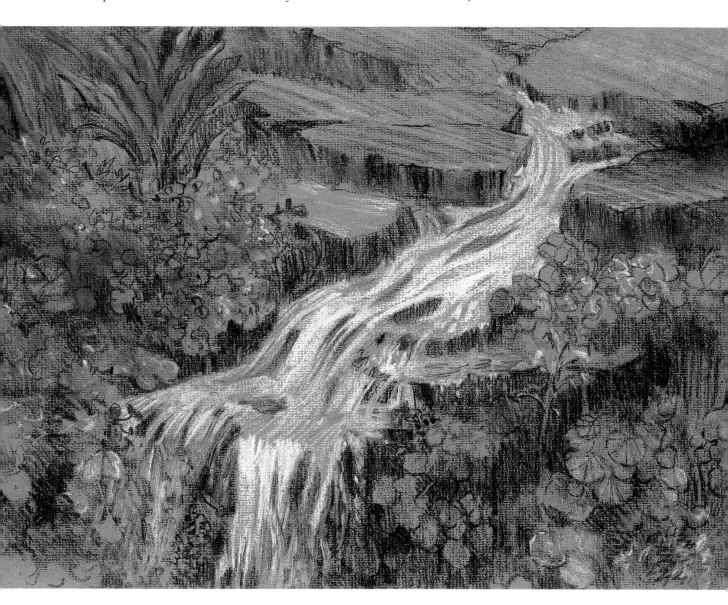

Still Life

If you are keen to draw flowers as a still life subject, you are going to need a selection of interesting containers.

Choosing a container
Do not spend a fortune in expensive antique shops: everyday objects around the home often make the best containers – and often the simplest of containers are the most successful.

Try out all the various jugs and pots that you have available in your home. Explore your kitchen, and you will be surprised at the variety of pans, bowls and cups that will hold a bunch

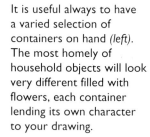

It is useful always to have a varied selection of containers on hand *(left)*. The most homely of household objects will look very different filled with flowers, each container lending its own character to your drawing.

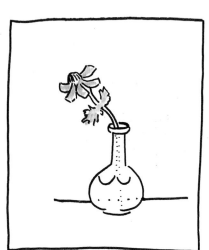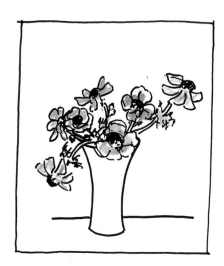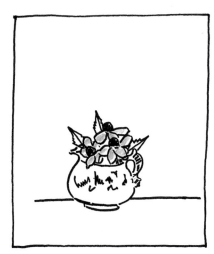

Pick a container to suit your arrangement. A narrow-necked vase is perfect for a single flower *(above)*, a tall container complements a long-stemmed bunch *(above centre)*, while a round bowl echoes the rounded shape of a posy *(above right)*.

An egg cup is the perfect holder for dainty flowers, such as a few daisies.

Here, the egg cup enhances the simple beauty of some blackberry flowers.

In this drawing, the same egg cup flatters a small bunch of 'shrinking violets'.

of flowers or a flowering plant. The humble egg cup looks delightful crammed with early spring flowers, for example, while a basket holding flowers looks romantic and summery.

Alternatively, to create visual tension in a drawing, choose containers that are in complete contrast to your flowers, combining, say, the small and squat with the tall and elegant.

Arranging flowers and plants
Experiment with different visual effects – a single bloom in a decanter or bottle can be more exciting than a dozen blooms in a vase.

Sometimes it is best to drop flowers haphazardly into a container, but if you do want to arrange a more elaborate bunch, remember the maxim of the professional flower arranger – that uneven numbers (three, five, seven, etc.) produce more interesting shapes than even numbers.

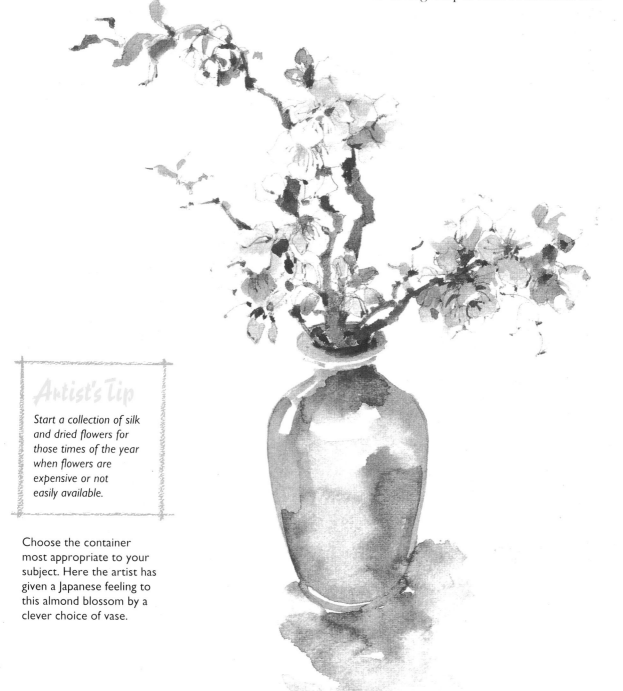

Artist's Tip

Start a collection of silk and dried flowers for those times of the year when flowers are expensive or not easily available.

Choose the container most appropriate to your subject. Here the artist has given a Japanese feeling to this almond blossom by a clever choice of vase.

Setting and background

Setting and background all affect the atmosphere of a still life, so decide on these before you begin. Where will you place your subject – on a sunny window sill, perhaps, or on a chair or lamplit table – and what will the background be – a lace cloth, say, or a tea towel?

Changing the lighting

Try drawing the same still life in different lights. For example, draw it on a window sill against the light, that is *contre-jour*, and then shut the curtains, draw the subject again and compare your two drawings. Altering the lighting will make the same still life look very different.

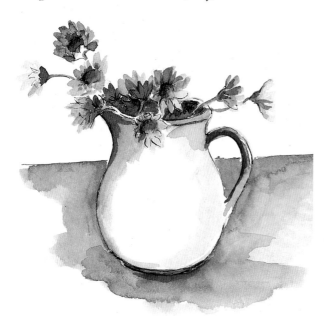

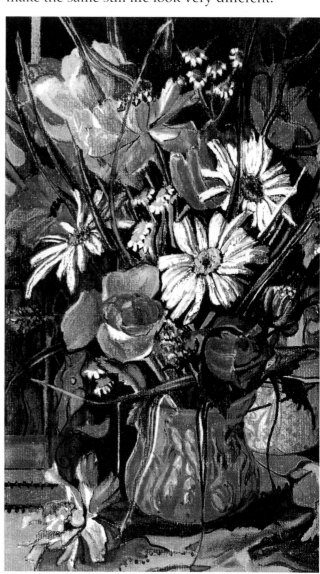

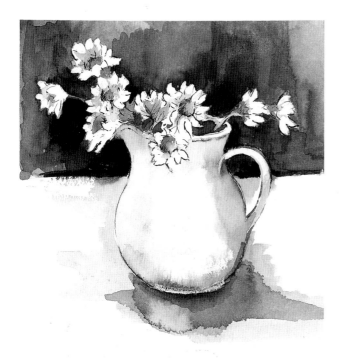

Set against the light, the flowers become flat silhouettes *(above left)*.

The same flowers against a dark curtain appear white and three-dimensional *(left)*.

A tonally dark background accentuates the whiteness of these flowers *(above)*. Spilling out to fill the picture area, the richness of this arrangement evokes a traditional Dutch still life.

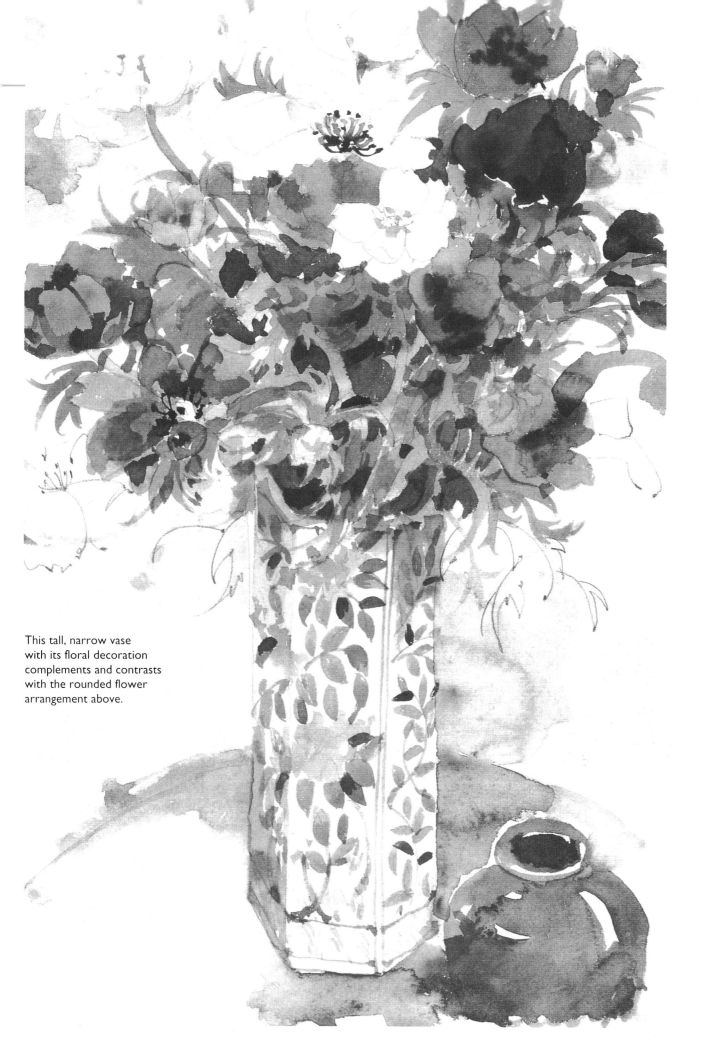

This tall, narrow vase
with its floral decoration
complements and contrasts
with the rounded flower
arrangement above.

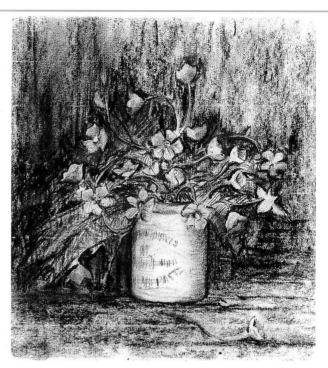

Light and atmosphere

When arranging your still life remember that it is your light source, more than anything else, that will lend atmosphere to your drawing. If you beam a strong light onto a still life in a darkened room, the most ordinary of subjects will be transformed.

In the first explanatory sketch below, you will see that line does little to create atmosphere. The second sketch, however, expresses the still life entirely in tone and is much more informative.

In these two sketches *(below* and *below right)*, note how little impact the line drawing has compared with the tonal sketch.

An unassuming crock of buttercups on a kitchen table is transformed by the addition of light and shadow *(right)*.

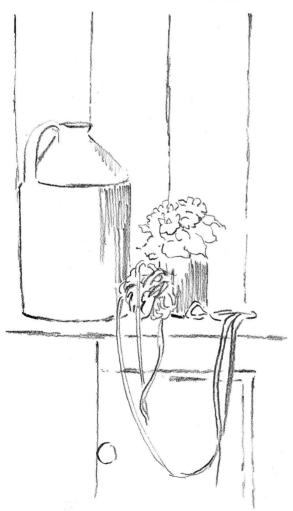

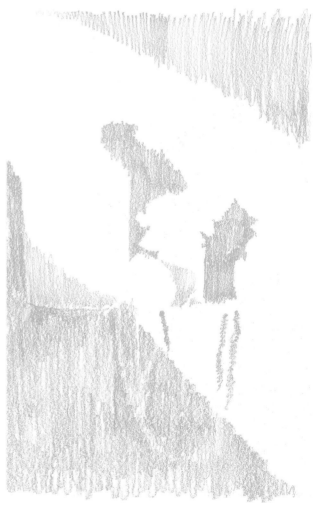

In this drawing of parrot tulips against a patterned background *(right)*, the artist has cleverly placed the bowl so that it obscures some of the pattern and prevents it from being over-dominant.

Artist's Tip

To keep your flowers fresh always spray them with an atomiser of water. Plants can also be kept fresh, wrapped, in the fridge overnight.

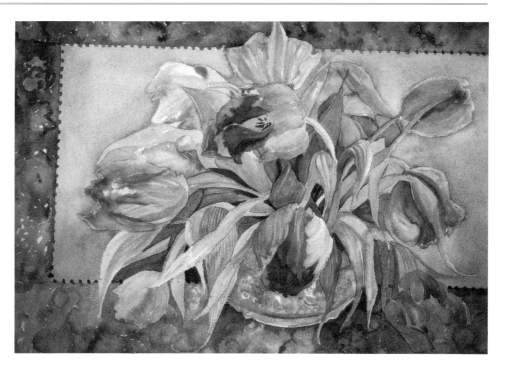

Shadows and patterns

If shadows are used creatively they will not only help you to sort out some of the problems of background to your still life but will also emphasize the strong verticals, diagonals and horizontal lines essential to a good composition. A simple anglepoise or spotlamp is easily and inexpensively available and will inspire you to great effects.

Many still-life subjects are enhanced by the addition of pattern. Patterned wallpaper will flatter the dullest of still lifes and a patterned cloth adds interest to a simple arrangement. Experiment by placing your subject against a variety of different backgrounds. Select contrasting fabrics – some striped, some spotted, etc. – and observe the effect on your still life. Horizontal patterns will enhance the vertical shapes while circular patterns will accent vertical stripes.

The final pastel version of the two sketches on the facing page, showing how tonal values have breathed light and atmosphere into this drawing *(left)*.

Working from Photos

Using a camera to record what you see can sometimes be useful. However, never rely entirely on the camera to help you draw, for it has many limitations. It can distort perspective, making the nearest petals on a flower look over-large, for example, and those in the background tiny. It can exaggerate light and dark, creating misleading tonal values. Working from a photograph, rather than sketching direct, is a 'second-hand' experience, and the resulting drawing can sometimes seem a bit flat.

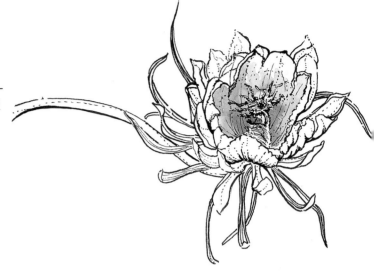

When to use a camera
The most effective use of your camera is in conjunction with your sketchbook. On the rare occasions that you have no time to sketch your subject, be creative with your photographs.

A camera can sometimes be helpful in capturing a fleeting or rare moment, as in the photographs here of Queen of the Night, a succulent which flowers only once a year and at night.

Working from the original plant, I sketched in pen and ink wash its main structure and leaf shapes *(above)*. The photographs *(below* and *below left)* provided the reference I needed to complete the details.

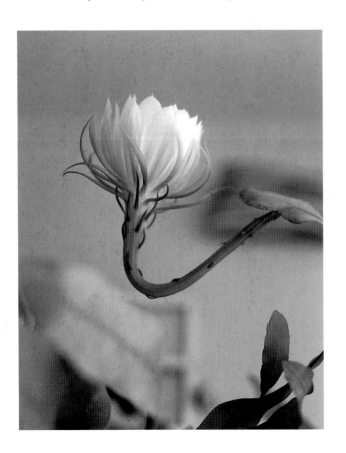

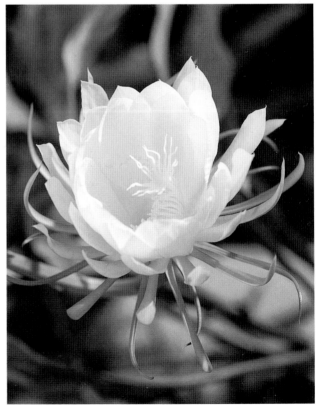

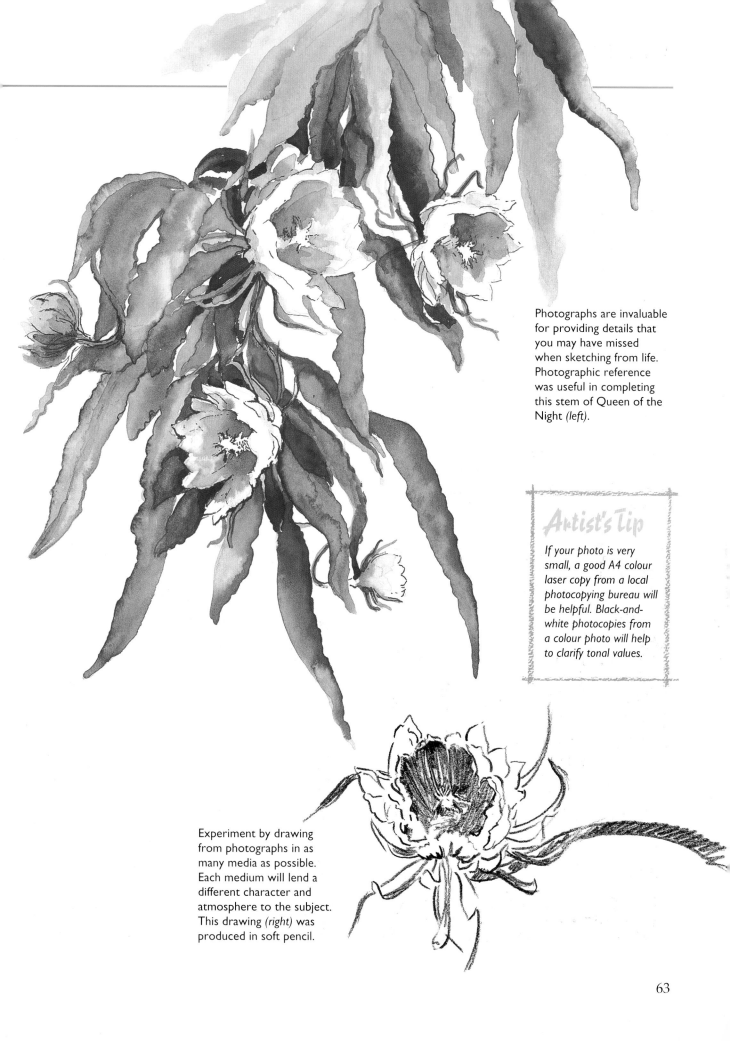

Photographs are invaluable for providing details that you may have missed when sketching from life. Photographic reference was useful in completing this stem of Queen of the Night *(left)*.

Experiment by drawing from photographs in as many media as possible. Each medium will lend a different character and atmosphere to the subject. This drawing *(right)* was produced in soft pencil.

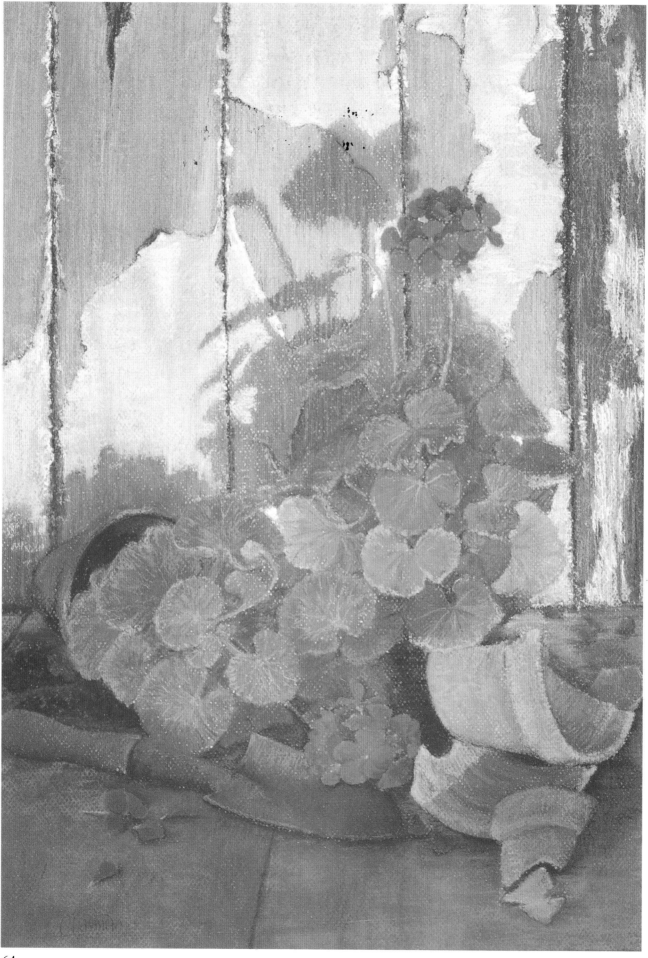